Richard Benjamin

Rhode Island

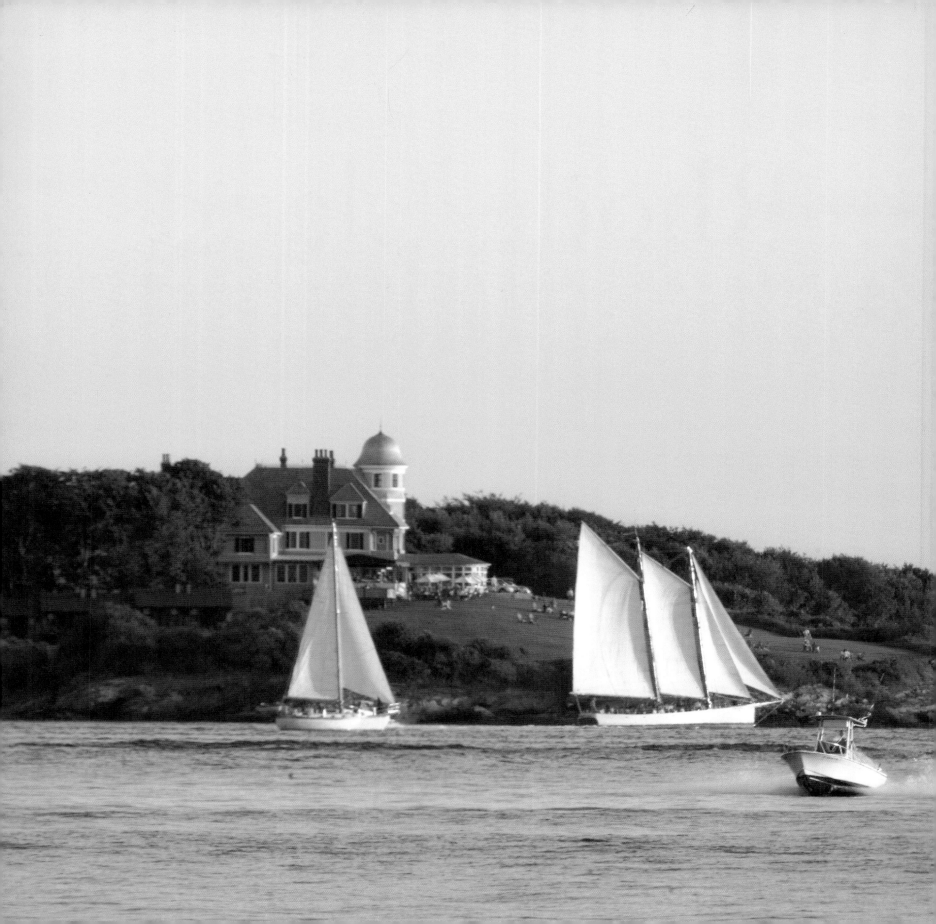

Rhode Island

Photographs by Richard Benjamin

Foreword by Phyllis Meras

Commonwealth Editions
Beverly, Massachusetts

To my wife and life partner, Trauti, and to our sons, Dan and Mike

Library of Congress Cataloging-in-Publication Data
Benjamin, Richard, 1939-
Rhode Island : photographs / by Richard Benjamin ;
foreword by Phyllis Meras.
p. cm.
1. Rhode Island—Pictorial works. I. Title.
F80.B45 2004
974.5'0022'2—dc22
2004008669

ISBN 1-889833-83-5
Jacket and interior design by Jill Feron
Book production by Anne Lenihan Rolland
Author photo by Trauti Benjamin
Printed in China

Published by Commonwealth Editions
an imprint of Memoirs Unlimited, Inc.
266 Cabot Street, Beverly, Massachusetts 01915
www.commonwealtheditions.com

Front jacket: Sunrise, Point Judith
Back jacket: State House, from outside Providence Place mall
Inside flap: Colonial-era home, Arnold Street, Providence
Title page: View across Narragansett Bay from Fort Wetherill Cove in
Jamestown to Castle Hill in Newport
Page 5: Goosewing Beach, Little Compton
Page 6: Evening bathers, Little Compton town beach

CONTENTS

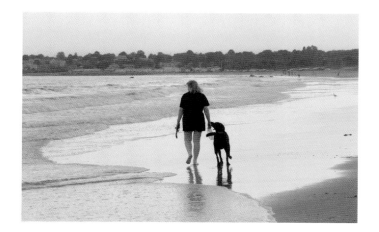

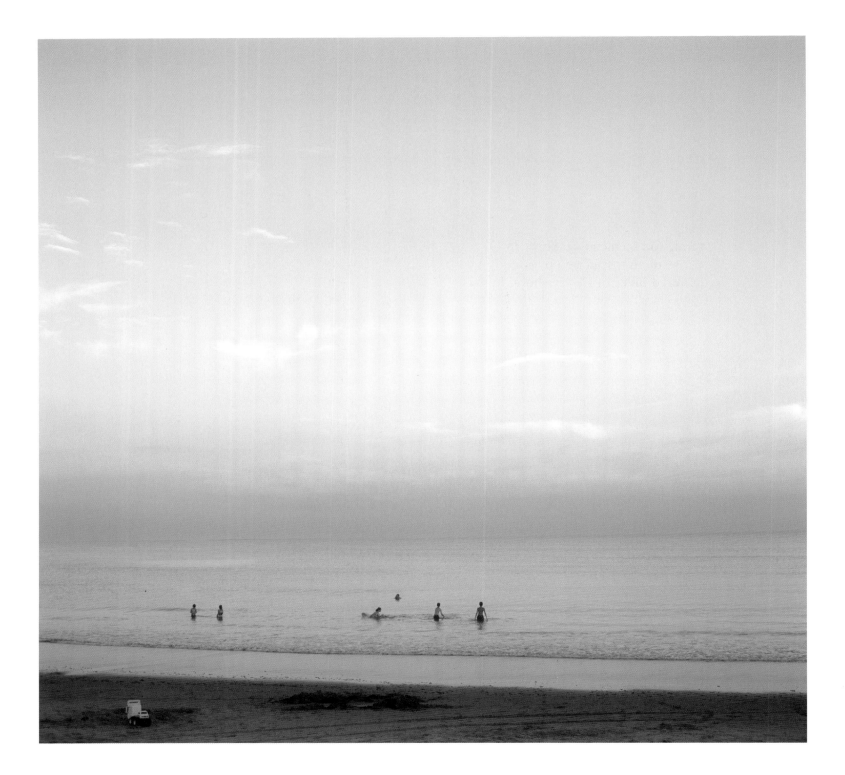

FOREWORD

RHODE ISLAND AND PROVIDENCE PLANTATIONS, as it is properly called, is the smallest state with the longest name. It is only forty-eight miles long by thirty-seven miles at its widest, but within its borders are some of the nation's finest historic, architectural, and scenic attractions.

Cut almost in two by sparkling Narragansett Bay, Rhode Island offers more than four hundred miles of silvery shore. In sheltered harbors, small boats bob at anchor and fishing trawlers rise and fall with the tide. Surf thuds on its rocky Atlantic headlands and white lighthouses flash warnings to sailors. In spring, apple blossoms nod along country roads while fall paints its maples, ashes, birches, and beeches crimson and gold.

The state was founded in 1636 by Baptist Roger Williams, a clergyman banished from the Massachusetts Bay Colony for his liberal ideas. The First Baptist Meeting House, built in 1775 in the capital city of Providence, is the oldest Baptist church in the nation, its graceful steeple inspired by St. Martin-in-the-Fields in London. The white and brown 1810 Episcopal Cathedral of St. John is a Georgian-style structure enlivened by a Gothic tower and Gothic decoration.

All along the streets and lanes of the old East Side of Providence rise handsome brick and clapboard examples of colonial, Georgian, Federal, and Greek Revival houses. Many of these reflect the wealth that the shipping trade brought in the eighteenth and nineteenth centuries.

In the granite Greek-Doric Athenaeum, the poet Edgar Allan Poe courted the writer Sarah Helen Whitman and was inspired by her to write the poem "Annabel Lee." The red brick buildings of eighteenth-century Brown University top the city's College Hill. The white marble dome of the Rhode Island State House is the second largest unsupported dome in the world, after that of St. Peter's in Rome.

In the late nineteenth century, Roger Williams's great-great granddaughter, Betsey, bequeathed part of the family farm to Providence for use as a public recreation area. And so was born Roger Williams Park: a Victorian park with a zoo and a carousel, a Temple to Music, a casino, and scenic ponds. Of a sunny summer afternoon, the park is a favorite place for Rhode Island families to go on outings.

But there is a modern Providence, too, much of it "born" during the city's celebrated renaissance in the 1990s. Daytime strollers can enjoy the cityscape from a walkway along the Providence River. On warm evenings, gondolas and water taxis carry passengers to the

WaterFire spectacle: bonfires that burn midstream up and down the river. New hotels have added silhouettes to the skyline. New restaurants and fashionable boutiques have joined the venerable bakeries and cheese stores that have long lured visitors to the Italian neighborhood of Federal Hill. Faux trolleys have become the latest mode of transportation to major historic attractions and art galleries.

It was the determined, stalwart settlers of Rhode Island who, on May 4, 1776, were the first English colonists in the New World to renounce their allegiance to British crown. Newport was soon occupied by the British and suffered greatly during the Revolutionary War. Fort Adams, which overlooks the entrance to Narragansett Bay and is one of the largest seacoast fortifications in the country, was largely destroyed by the British. (Later, however, it was restored and during the early years of the Civil War served briefly as the U.S. Naval Academy.)

After the Civil War, Newport became an elegant summer resort with imposing ocean-front mansions. The grandest of these—more than a dozen are open to the public in summer—is the four-story, seventy-room limestone "palace" called The Breakers. It was built by railroad tycoon Cornelius Vanderbilt in 1895. Today's Newport is the yachting capital of the nation; twelve-meter yachts can often be seen tacking in its blue-green waters.

Above the Blackstone River in the city of Pawtucket is Slater Mill, the first factory in the country to make cotton thread with water-powered machinery, and therefore deemed the birthplace of the American Industrial Revolution. Farther up the river is French-Canadian Woonsocket, once a major wool manufacturing center. A highlight there is the restored 1920s-era Stadium Theatre, where vaudeville was long performed.

But Rhode Island's quiet villages and towns are surely as attractive as its cities. Linked to Newport by bridge is its rural neighbor island, Jamestown, purchased from the Narragansett Indians in 1657 by a group of Newporters, including Benedict Arnold, the great-grandfather of the Revolutionary War traitor. In Bristol are tall white houses built with money from privateering and the slave trade. At Blithewold Mansion there, towering trees shade the twenty-two acres of grounds. The mansion itself, in the style of a seventeenth-century English manor house, is surrounded by gardens bright with flowers in spring and summer.

In little North Kingston, eighteenth-century artist Gilbert Stuart, particularly renowned for his portraits of George Washington, grew up at a snuff mill that still stands down a sylvan road. Gleaming brass knockers brighten the doors of yellow and white clapboard homes in Wickford. The town's Old Narragansett Church, built in 1707 and the oldest Episcopal church north of Virginia, has a silver baptismal font and communion service presented to it by England's Queen Anne. At the Silas Casey Farm in Saunderstown, visitors can still see how a seventeenth-century farm was worked.presented to it by England's Queen Anne. At the Silas Casey Farm in Saunderstown, visitors can still see how a seventeenth-century farm was worked.

Rhode Island's major fishing port is at Galilee on Point Judith Pond, where casual diners can enjoy meals of fresh fish. From Galilee, there is ferry service to the moors and rolling hills and cliffs of 10.8-square-mile Block Island.

Watch Hill, after Newport, is Rhode Island's most select beach resort, with turn-of-the-century "cottages" and grand hotels of another era overlooking Little Narragansett Bay and the Atlantic. Its beachfront Flying Horse Carousel has animals made in New York City in 1879 that are said to be the oldest in the country.

Bordering the green pastures of Little Compton are enough ancient stone walls to reach to Boston and back. In sleepy Tiverton the traveler can take soothing drives past pretty ponds. In Middletown, the Norman Bird Sanctuary's spectacular Hanging Rock overlooks the Atlantic from a height of fifty feet.

On the winding back roads of Exeter and Glocester, Smithfield and Coventry, Foster, Lincoln, Cumberland and Johnston, old farms and old homes suddenly come into view around corners.

Richard Benjamin has captured all this—from old Providence to Newport and the rest of the coast, through all the back roads and back to the new Providence—in his eloquent photographic tribute to the natural and the manmade beauty of lovely, unsung little Rhode Island.

Phyllis Meras

PROVIDENCE:
THE CAPITAL CITY

What many people find attractive about Providence are its relatively small scale and cultural diversity. From the elevation of Prospect Park, you can view the entire skyline from Capital Hill to the north, to the "skyscrapers" of the financial district directly west, to the spire of the colonial-era First Baptist Church to the south. With its historic architecture and restored homes and with new buildings and parks created during its recent "renaissance," Providence stands firmly with one foot in the past and one in the future.

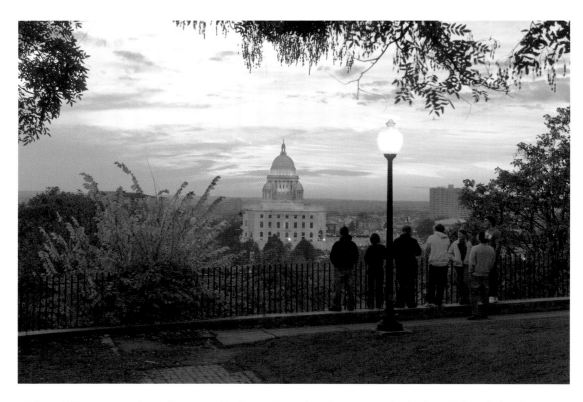

(Above) Young people at Prospect Park on Congdon Street watch the last light of the day fade behind the State House. The park is a popular spot at sunset because of its view toward the west.

(Right) The state capitol building was completed in 1904. One of the new trolleys is in the foreground.

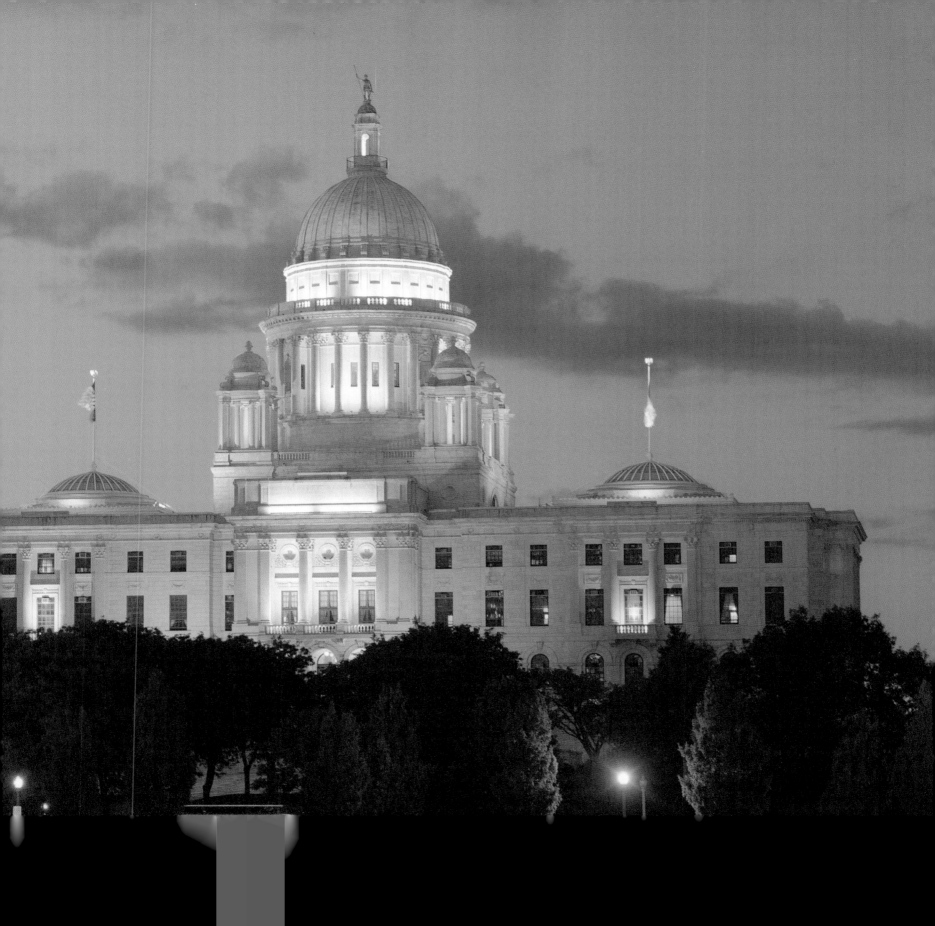

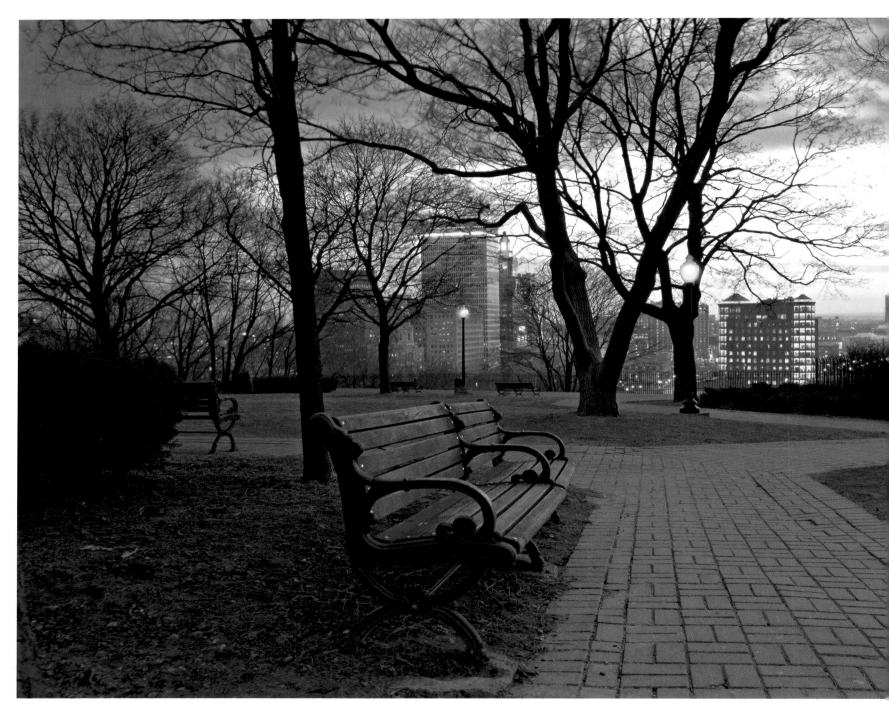

A statue of Providence's founder, Roger Williams, looks out over the city skyline from Prospect Park.
To the left is the financial district and, to the right, Capitol Hill.

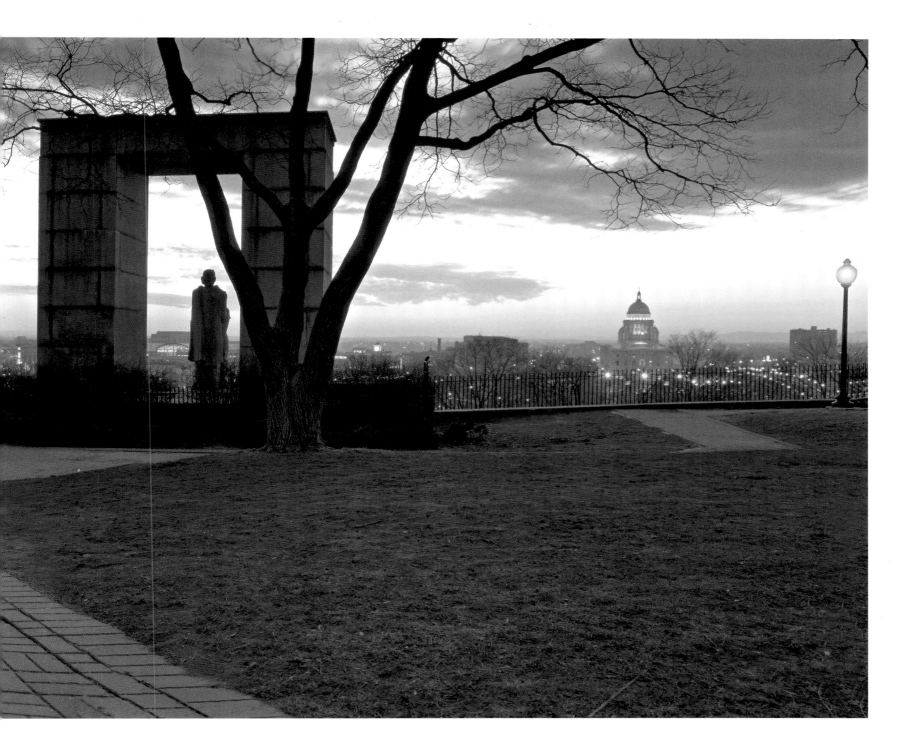

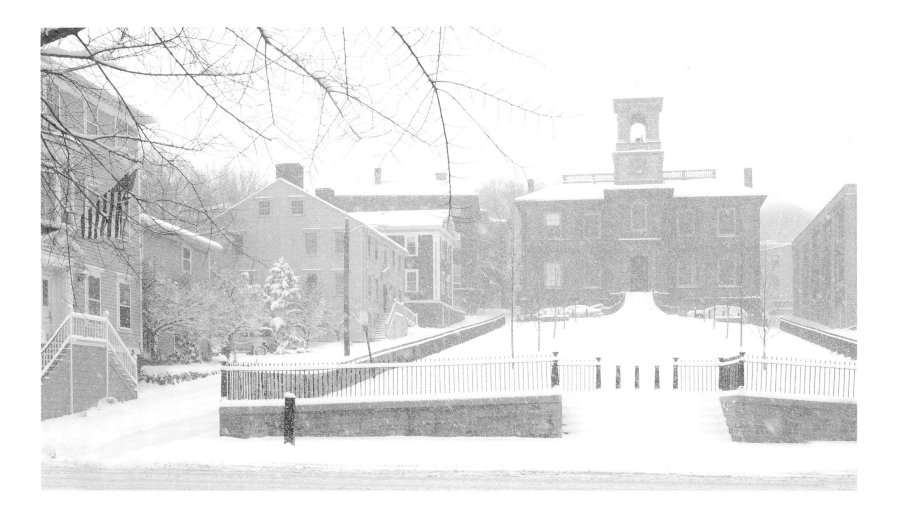

Exterior of the Old State House on Benefit Street, built in 1762. Here, on May 4th, 1776, Rhode Island was the first colony to renounce its allegiance to the King of England.

(Right) The Secretary of State's room, inside the Old State House.

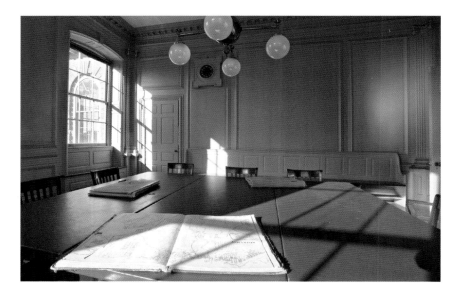

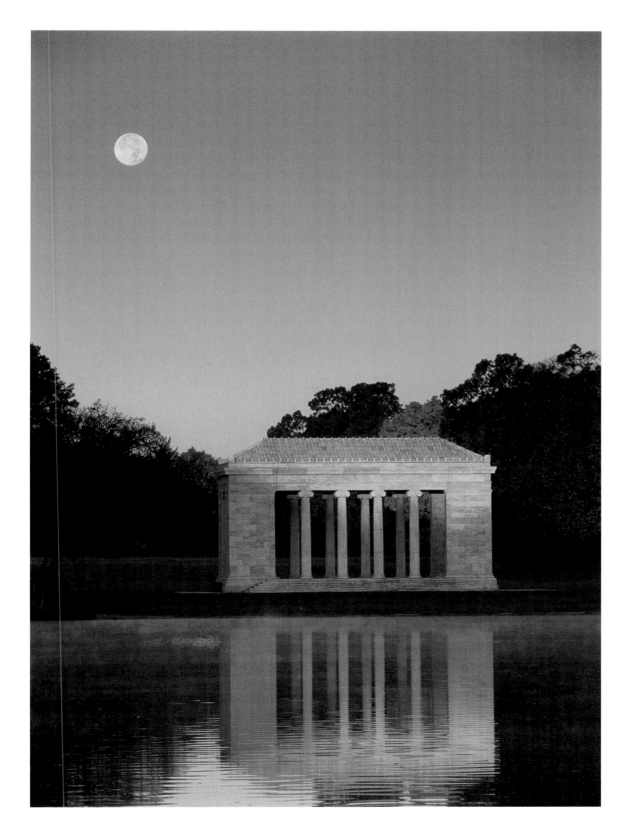

The moon sets behind
the Temple to Music at
Roger Williams Park.

15

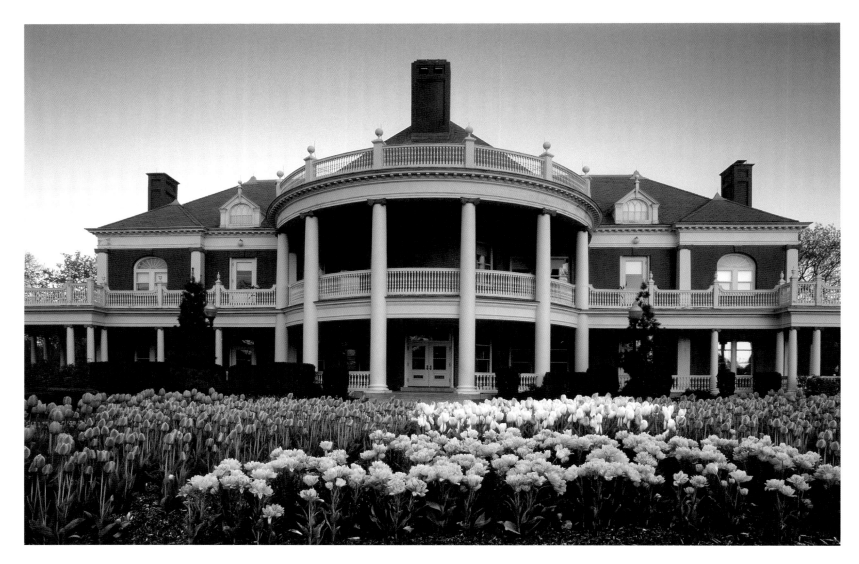

The Casino at Roger Williams Park, a popular site for many events

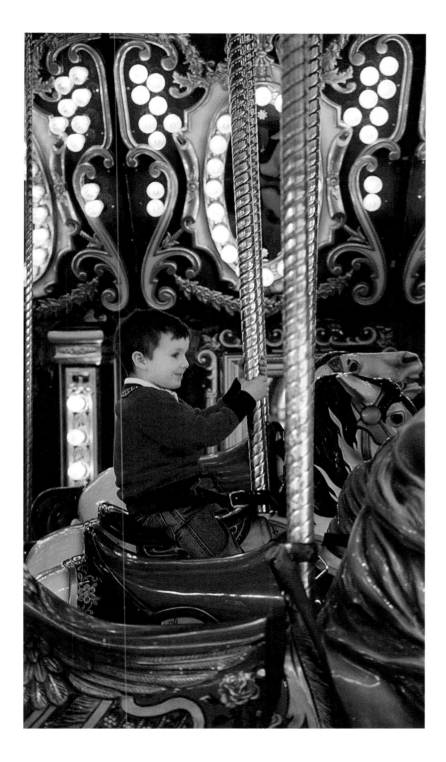

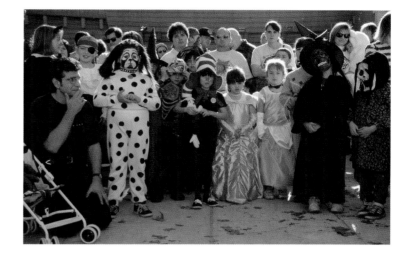

(Left) At Roger Williams Park, a young boy waits for the carousel to start. This is a modern carousel, built in the 1980s.

(Right) A group of youngsters competing in a Halloween costume contest at the Roger Williams Park Zoo await the decision of the judges.

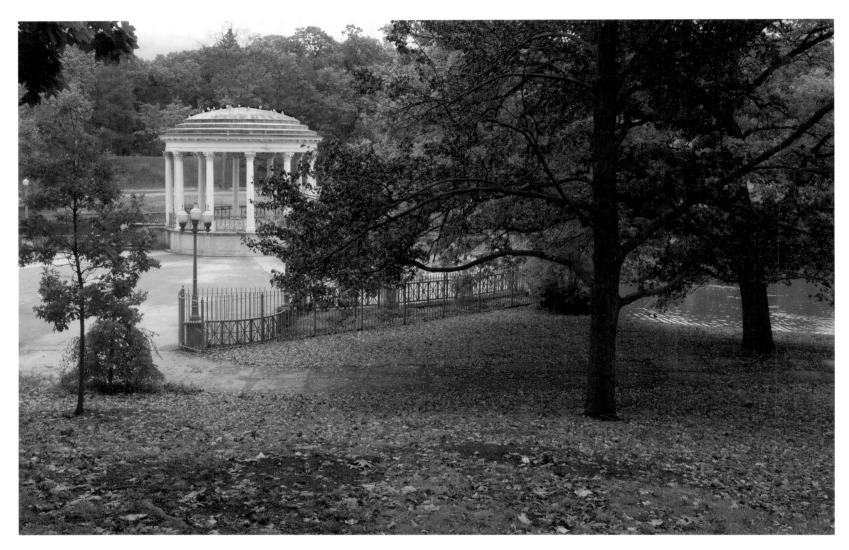

Bandstand, Roger Williams Park

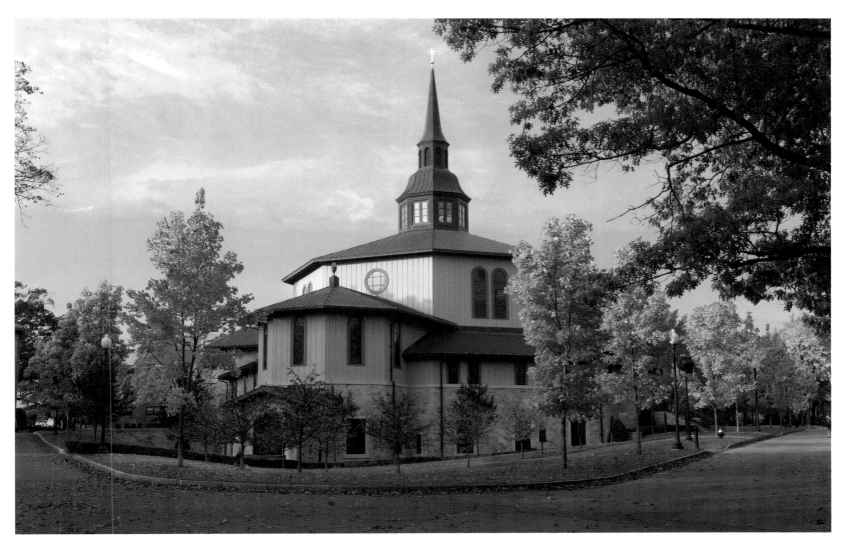

St. Dominic Chapel on the Providence College campus

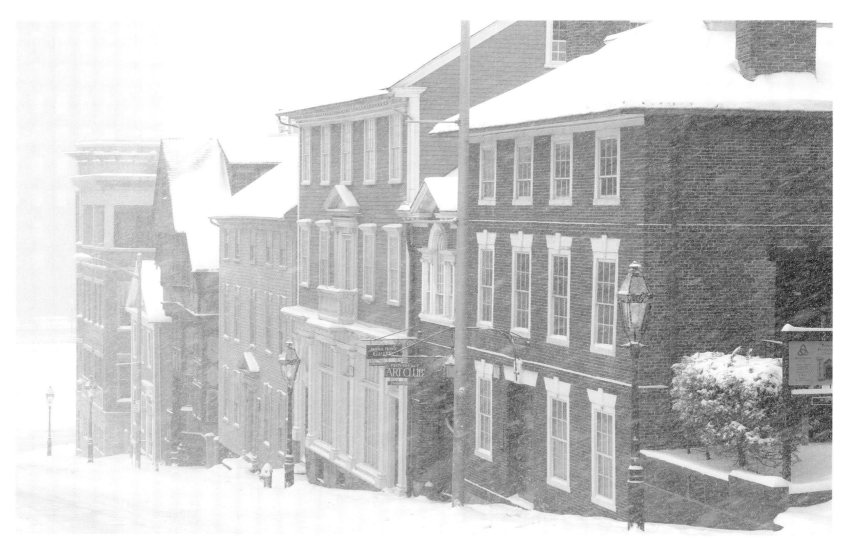

A view down Thomas Street, with buildings of the Providence Art Club

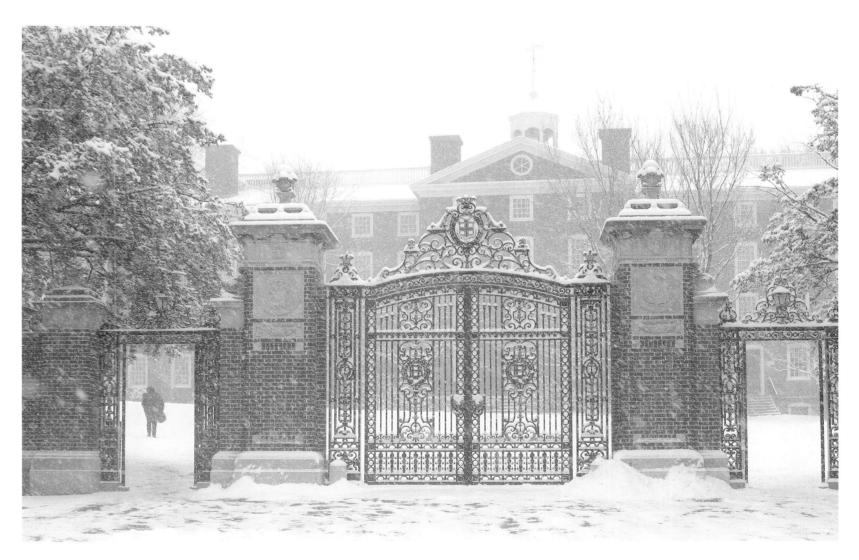

Van Wickle Gates, Brown University

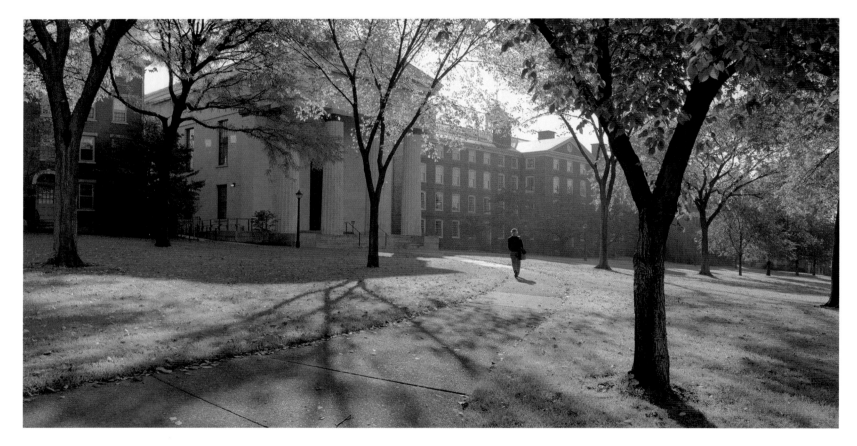

Front campus, Brown University, in autumn. The building directly behind the walker is University Hall, one of the first buildings of what was first called Rhode Island College. It was used as a barracks and a hospital for American and French soldiers during the Revolutionary War.

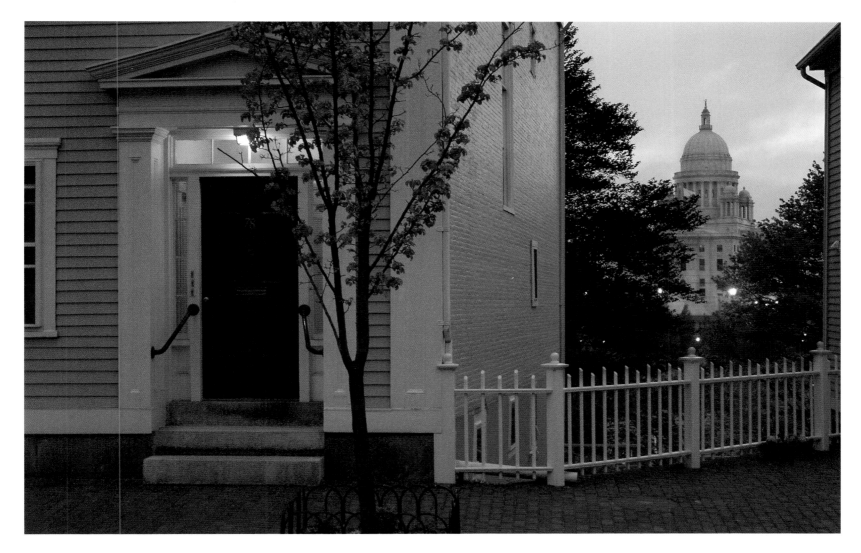

The capitol building, between two Greek Revival houses on Benefit Street. Benefit Street is known as Providence's "Mile of History" because of the many restored houses from different periods of the city's history.

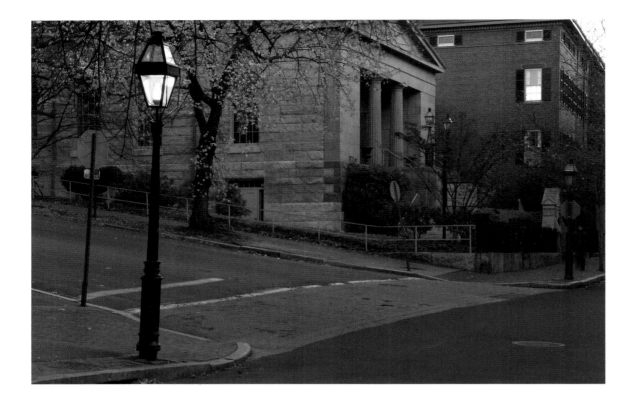

(Above) A view of the
Providence Athenaeum.
Founded in 1753, it is the
fourth oldest subscription
library in the country.
Built in 1838, it was once
frequented by Edgar
Allan Poe.

(Right) A student walks
along Benefit Street.

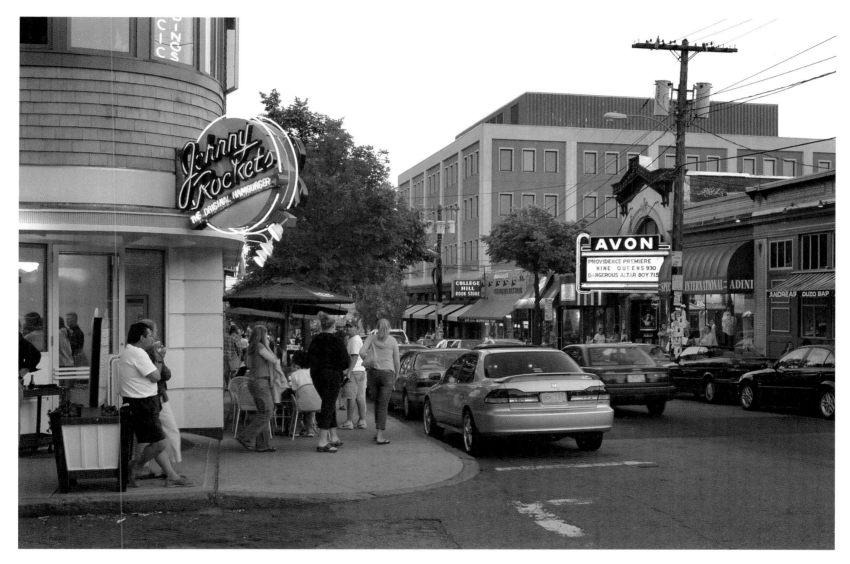

A summer evening on Thayer Street, popular because of its many restaurants.
The Avon Cinema, one of the city's oldest, shows mostly art films.

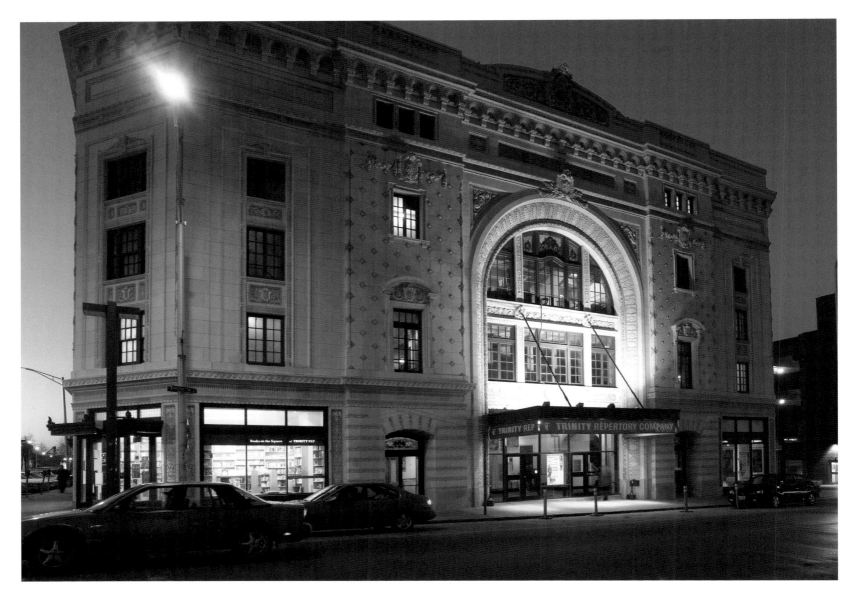

The former Majestic Theatre on Washington Street has been the home of the Trinity Repertory Company, one of the country's finest regional repertory companies, since the early 1970s. The company was founded in the early 1960s; its first home was in Trinity Methodist Church—hence the name.

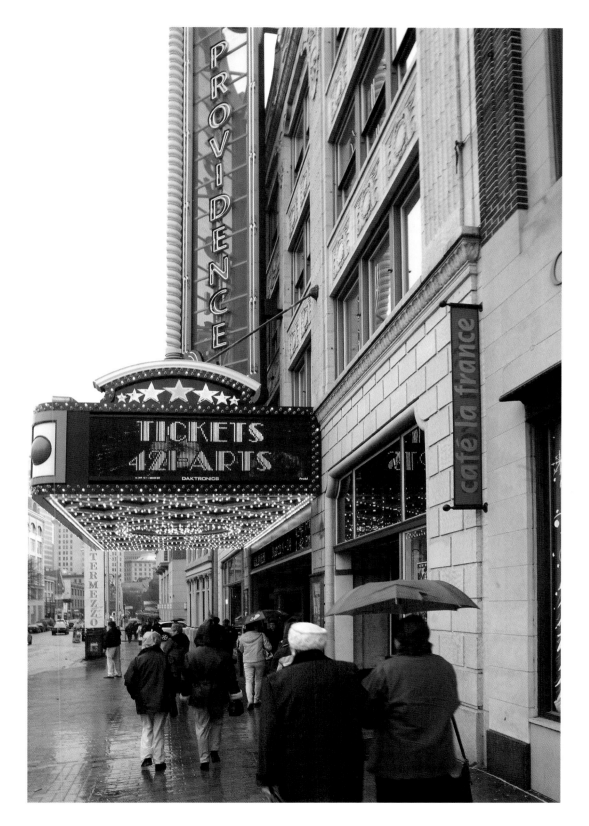

People arriving for a matinee performance at the Providence Performing Arts Center. Built in 1928 as a Loew's Theater, it was rescued from demolition and restored to its original grandeur.

A late afternoon conversation outside Scialo's Bakery on Atwells Avenue in the city's
Federal Hill area, know for its fine Italian restaurants

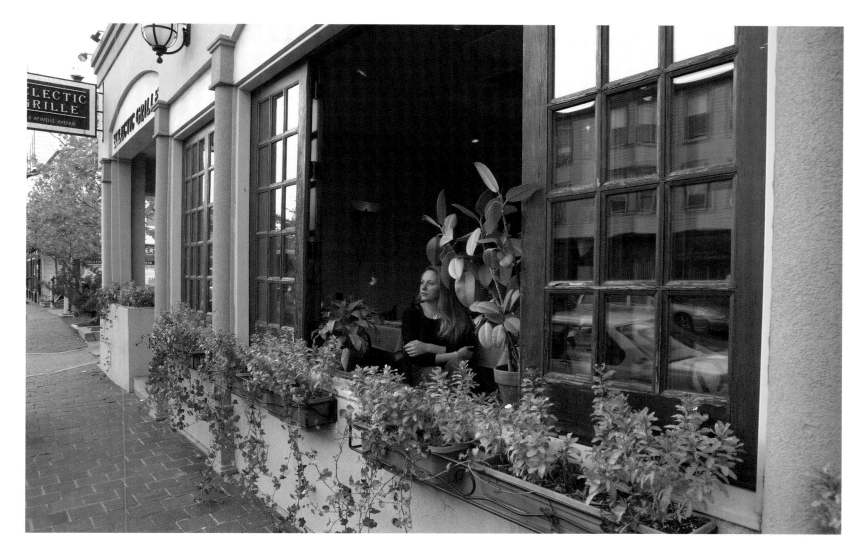

A hostess at the Eclectic Grille on Atwells Avenue enjoys a brief quiet time before the evening rush begins. Federal Hill is noted for its many fine places to dine.

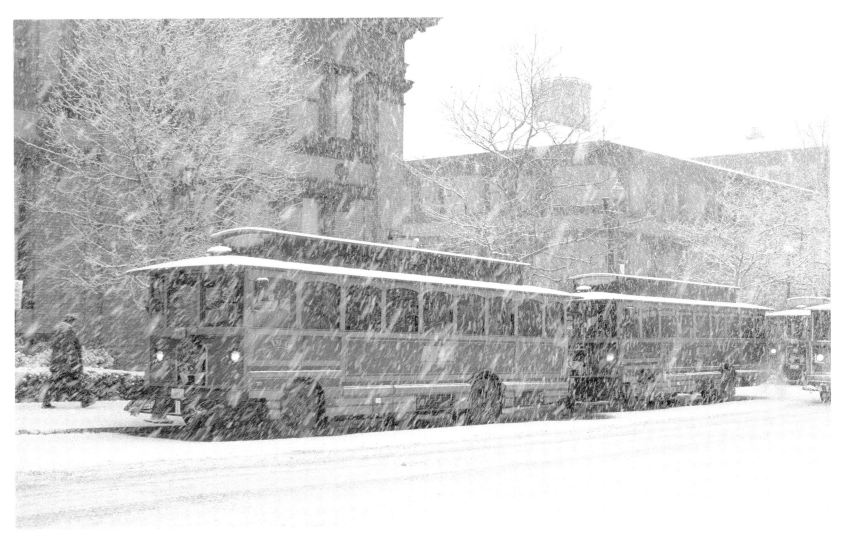

A row of trolleys gathered for the snowy afternoon commuters. The trolleys, which operate mostly around Providence proper, replaced a fleet of aging buses.

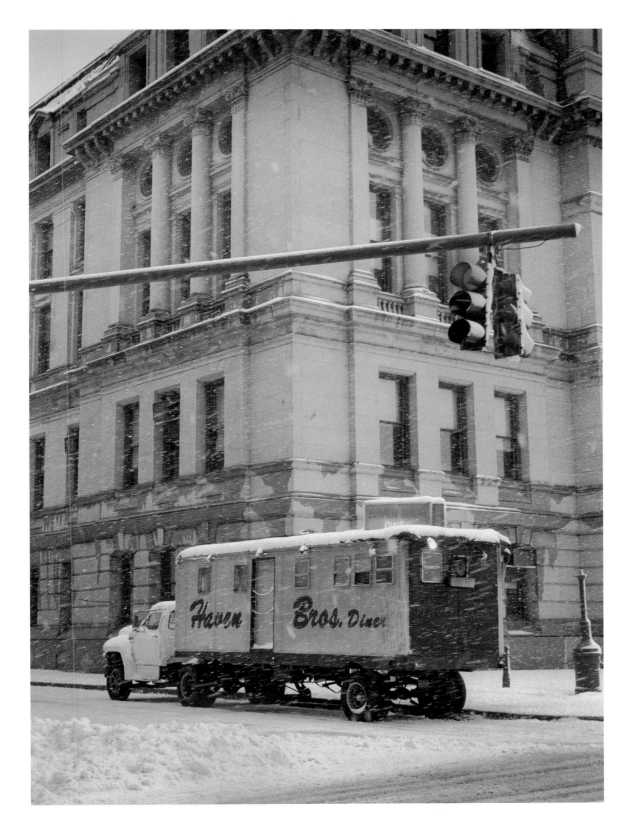

One of the oldest mobile diners, the Haven Brothers Diner, pulls into its parking spot by City Hall at five o'clock daily. Because of its late-night hours, it has been the favorite of revelers over many generations.

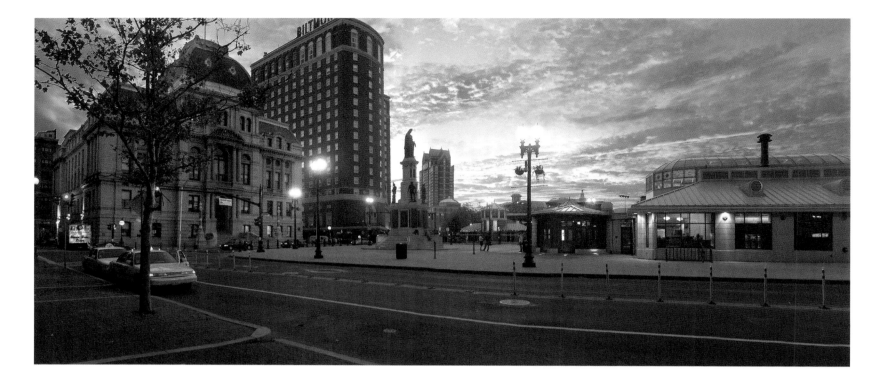

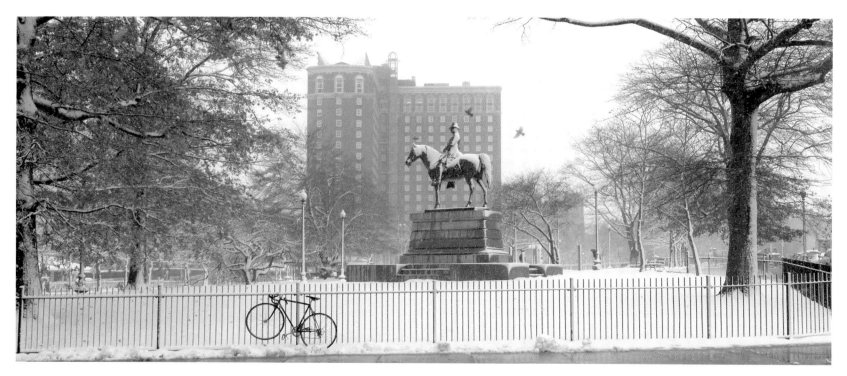

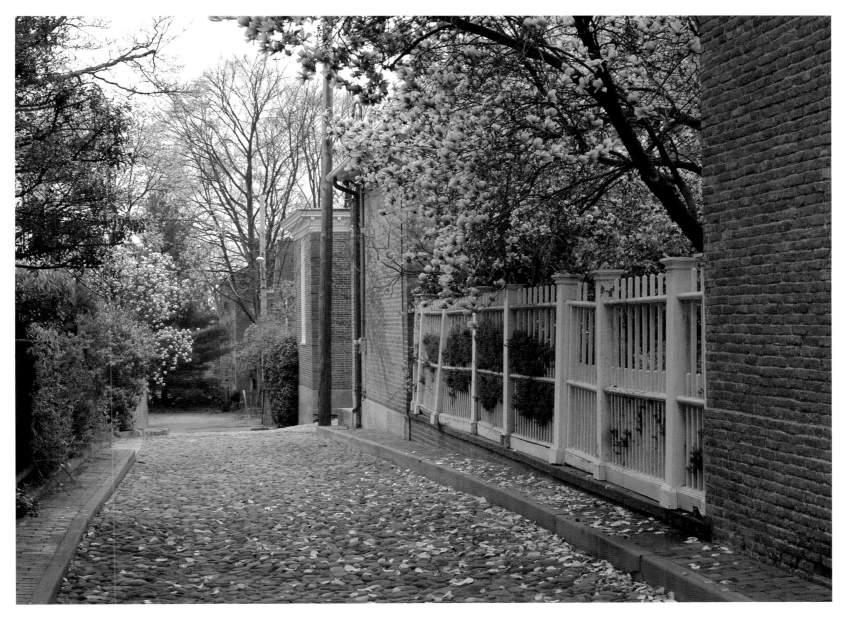

A springtime view of Neighbor's Lane, one of the city's oldest alleys, still paved with cobblestones

(*Left above*) Kennedy Plaza, showing City Hall (built in 1878) and, to the extreme right, the new bus station. Once known as "Exchange Place," the plaza has long been a transportation hub for Rhode Island. The smaller building was once a comfort station for those waiting for buses.

(*Left below*) A view of Burnside Park with the statue of Civil War general Ambrose Burnside. In the background is the city's oldest hotel, the Biltmore.

A restored Victorian "painted lady" on Parade Street in the Armory District

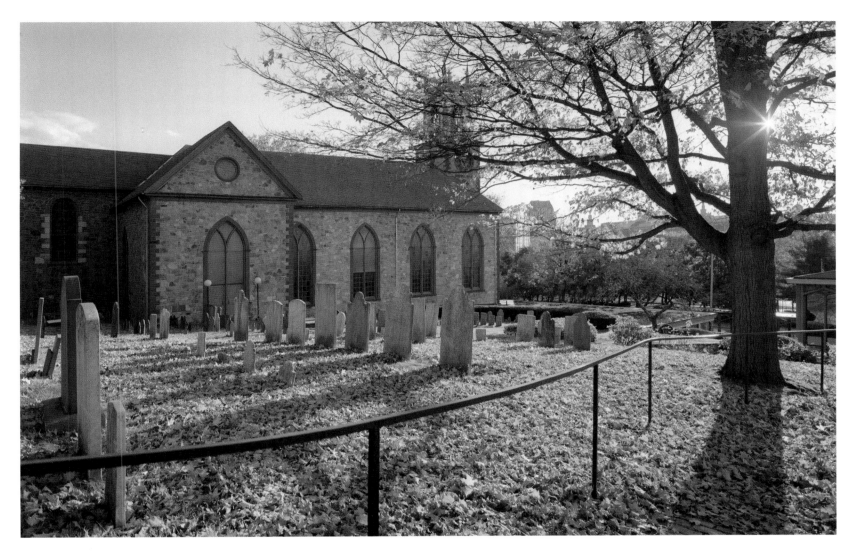

The churchyard for the Episcopal Cathedral of St. John. This view dates to the early nineteenth century, but glimpses of the "Renaissance City" can be seen between the branches of the tree.

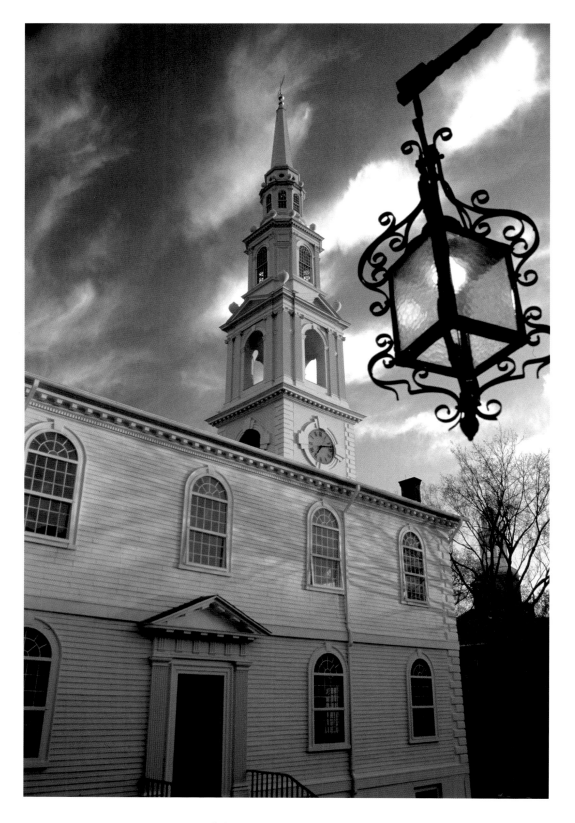

The north side of the First Baptist Church with the lantern of the Providence Art Club in the foreground

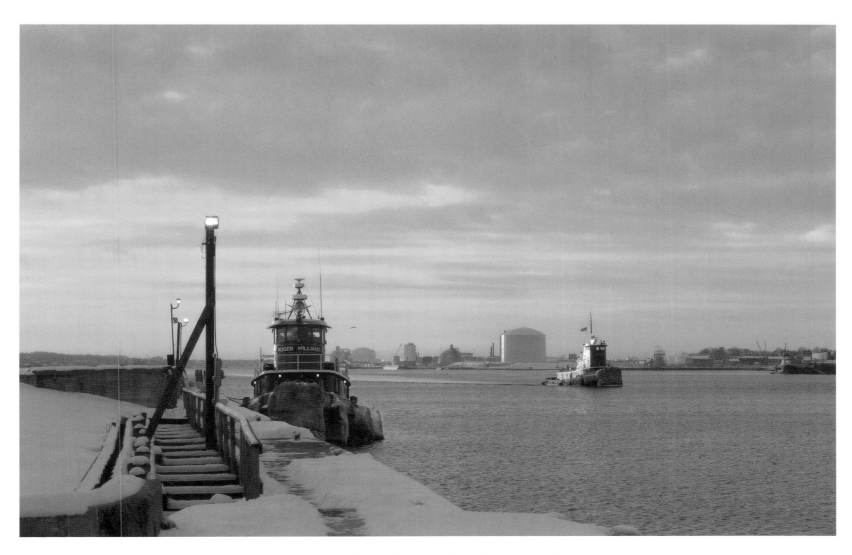

The port of Providence at dawn, looking south

ALONG
THE COAST

With its long coastline and many natural harbors, Rhode Island offers much to lovers of the ocean: fishing and shellfishing (and excellent seafood); boating and yachting; lighthouse beacons; long stretches of beautiful beaches. Rhode Island is truly the Ocean State.

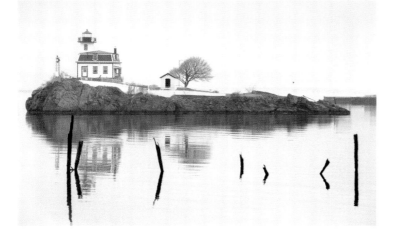

A view of the Warren River from Mathewson Road in Barrington, looking toward Warren

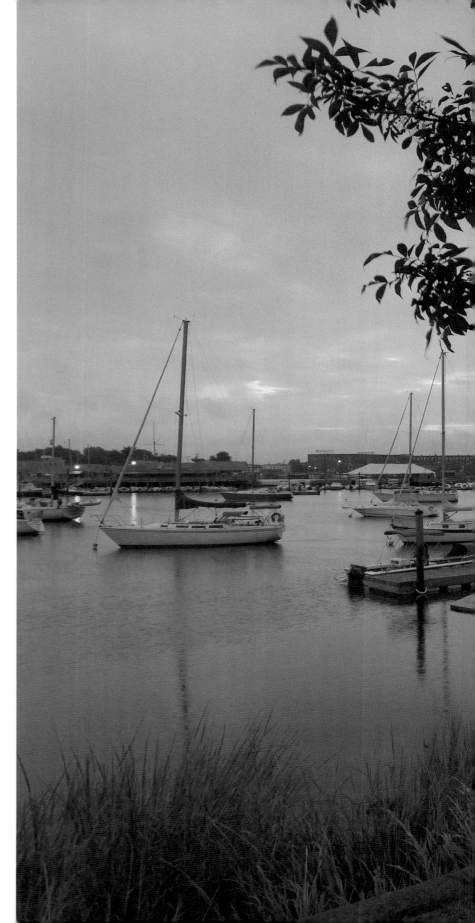

(Right) Pomham Light, in the Riverside section of East Providence

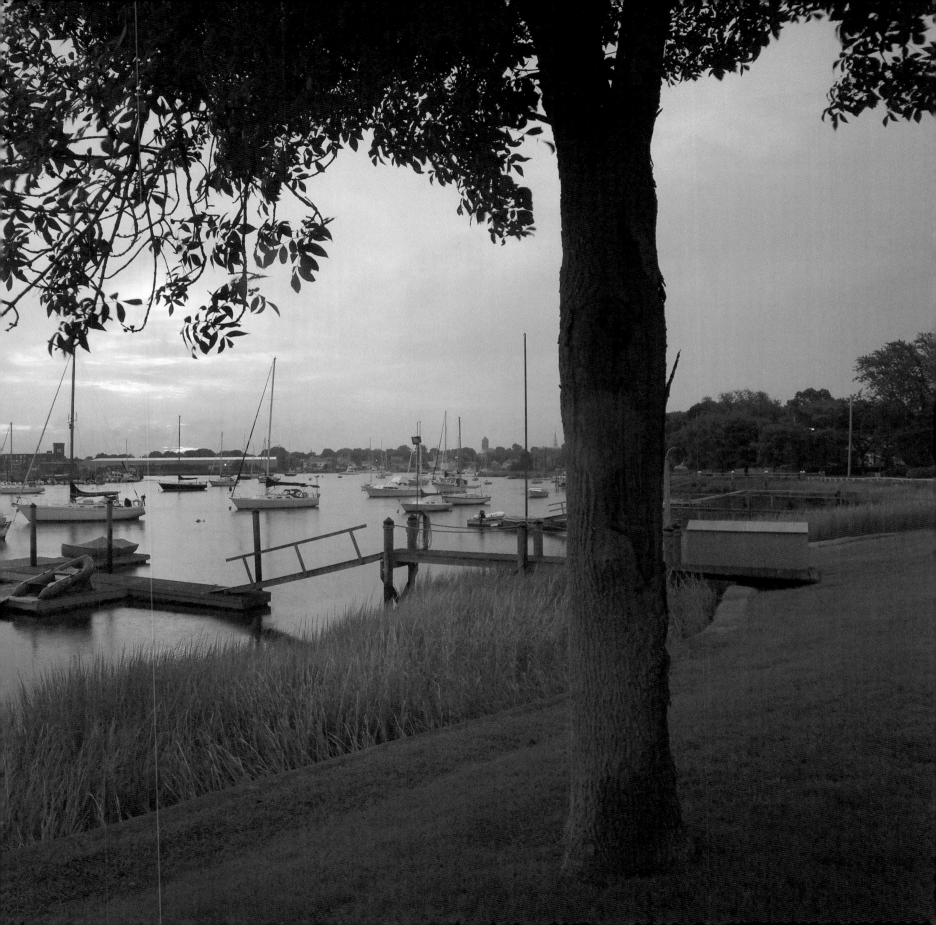

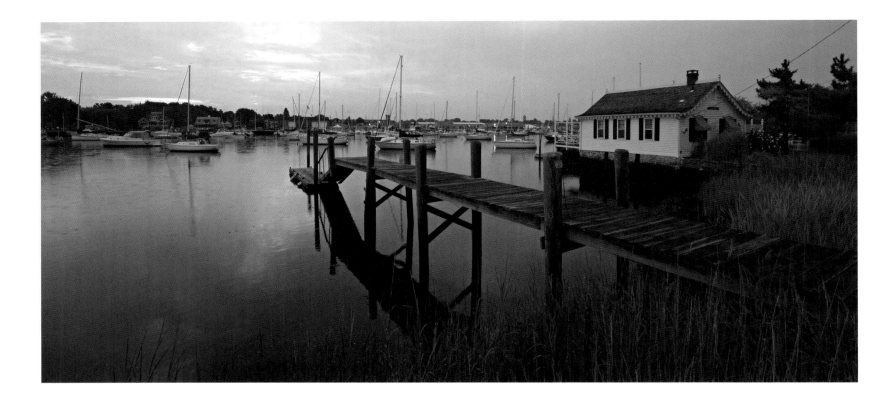

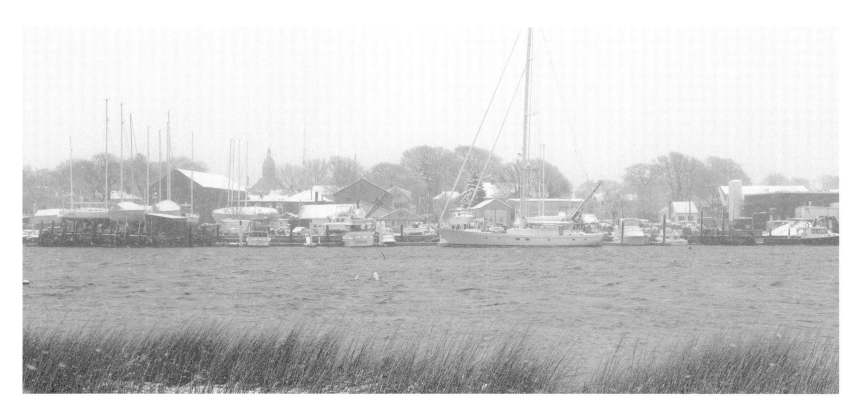

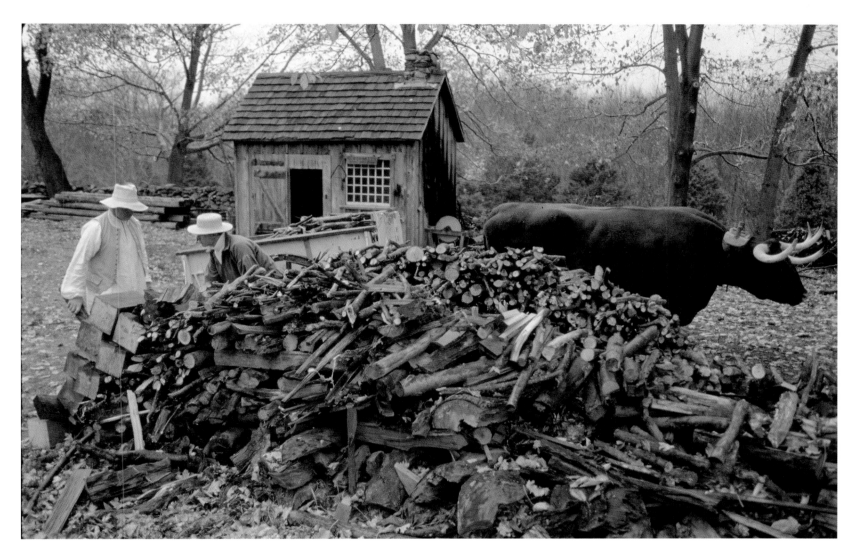

A demonstration of wood-gathering at Coggeshall Farm in Bristol, an eighteenth-century museum farm
worked in the manner of the 1700s and 1800s

(Left above) Looking across the Warren River from Mathewson Road to the Barrington Yacht Club.
The structure at right, now a private home, was the yacht club's original building.

(Left below) The waterfront of Warren as seen from Mathewson Road in Barrington

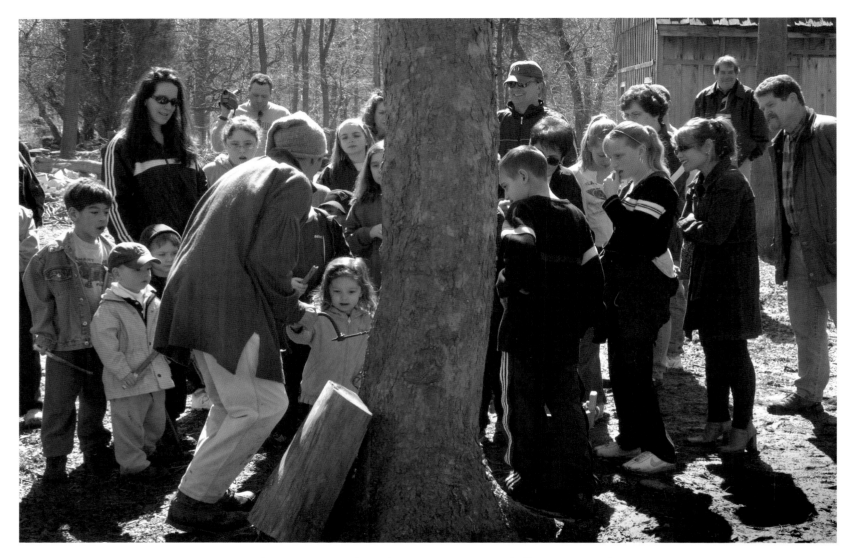

A demonstration of maple sugaring at Coggeshall Farm, Bristol

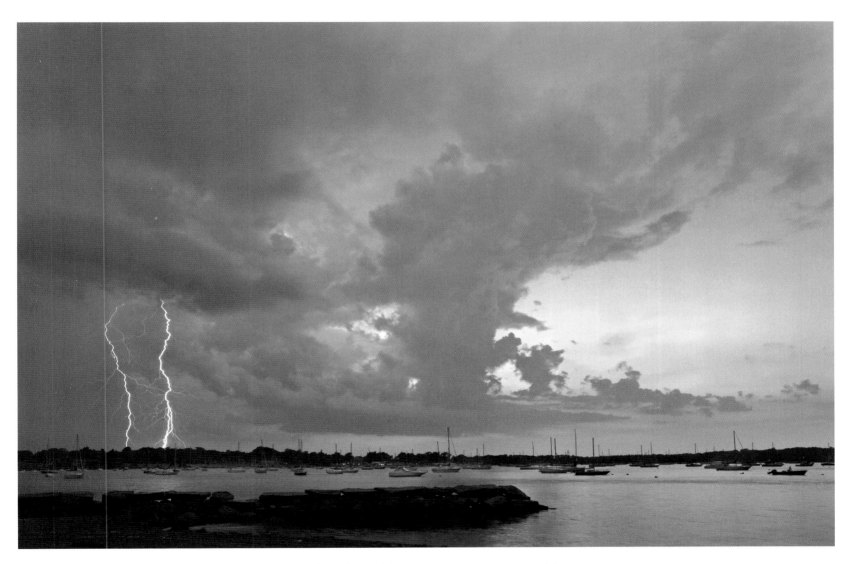

Bristol Harbor with a summer storm approaching

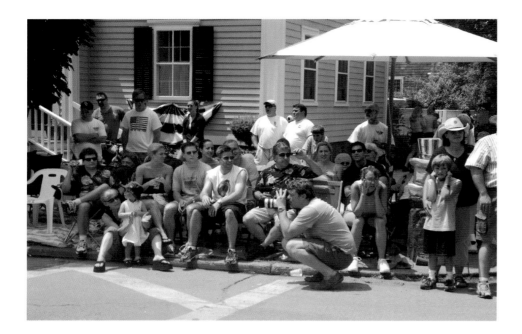

(Left) The Couto Family of Bristol watches the Fourth of July parade on Hope Street. Following the tradition of generations of Bristol residents, they staked out this spot by setting out blankets and chairs before sunrise.

(Below) A marching band passes one of the many fine homes along the route in Bristol.

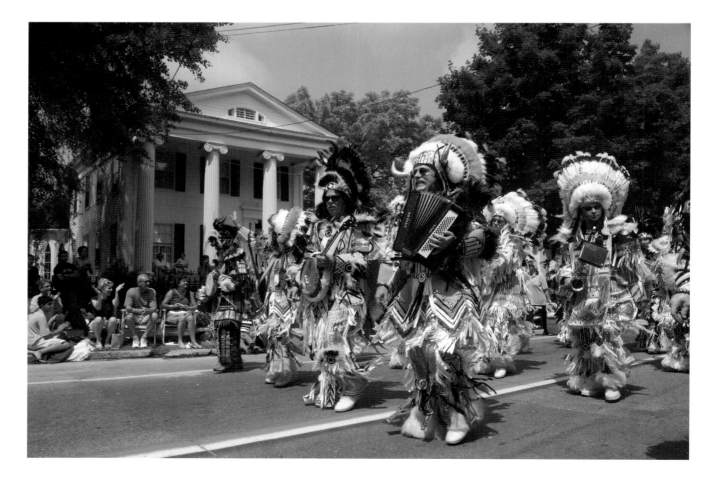

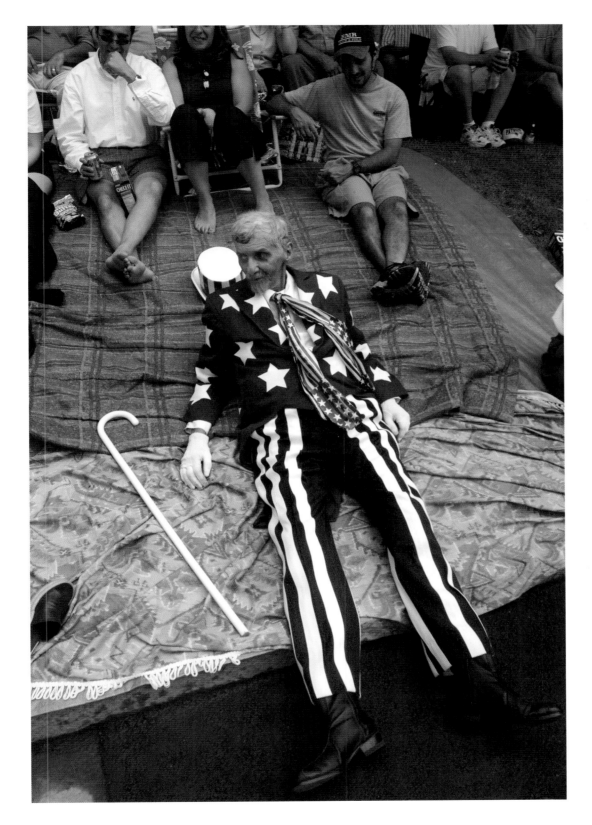

A tired Uncle Sam takes
a break during a backup in
the parade.

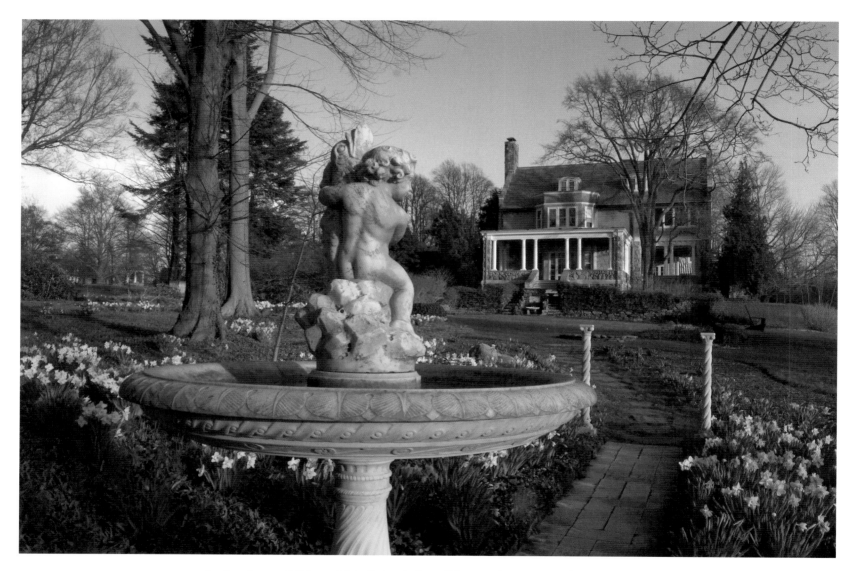

Springtime at Blithewold in Bristol. A well-kept arboretum with a view onto
Narragansett Bay, it is a favorite site for weddings.

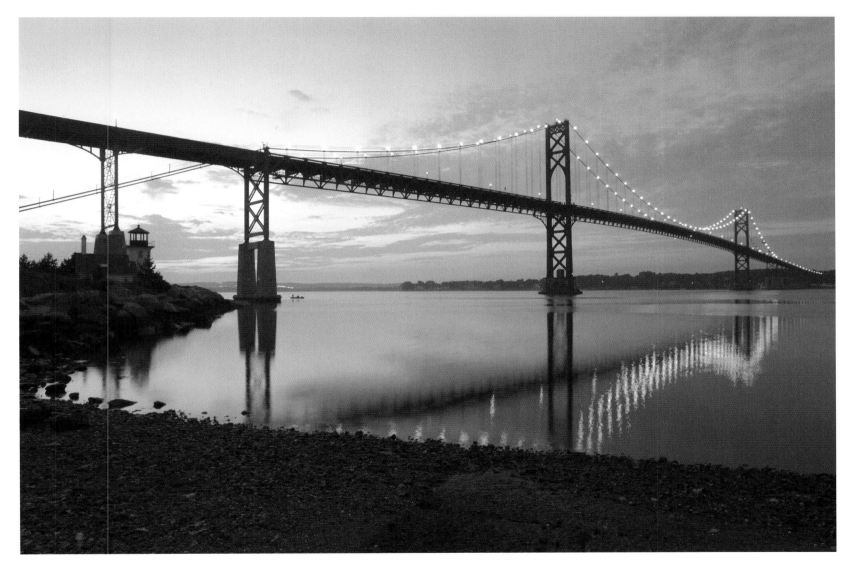

The Mt. Hope Bridge looking north at dawn, with a pair of fishermen beneath the span.
The lighthouse, now a private home with a unique view, was built in 1855.

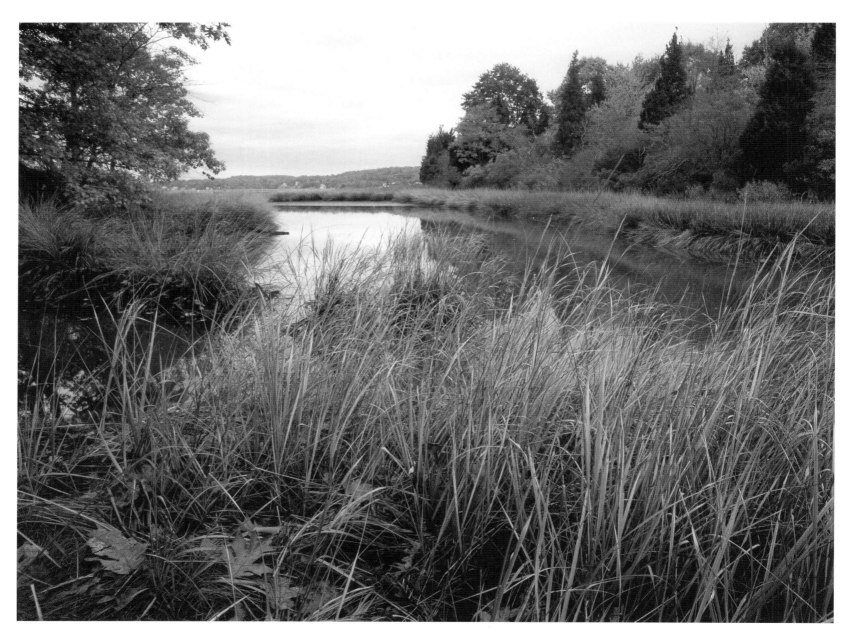

Nannaquaket Pond, Tiverton

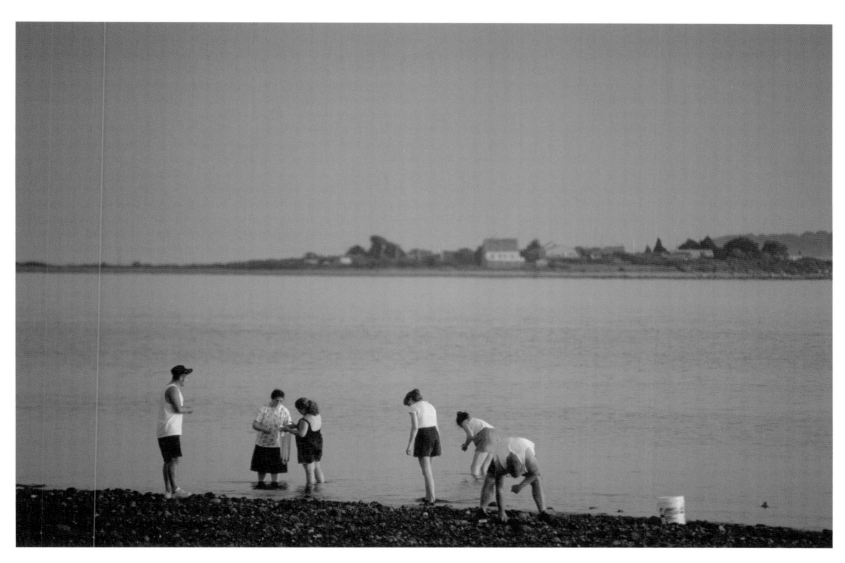

Gathering quahogs at Seapowet Point, Tiverton

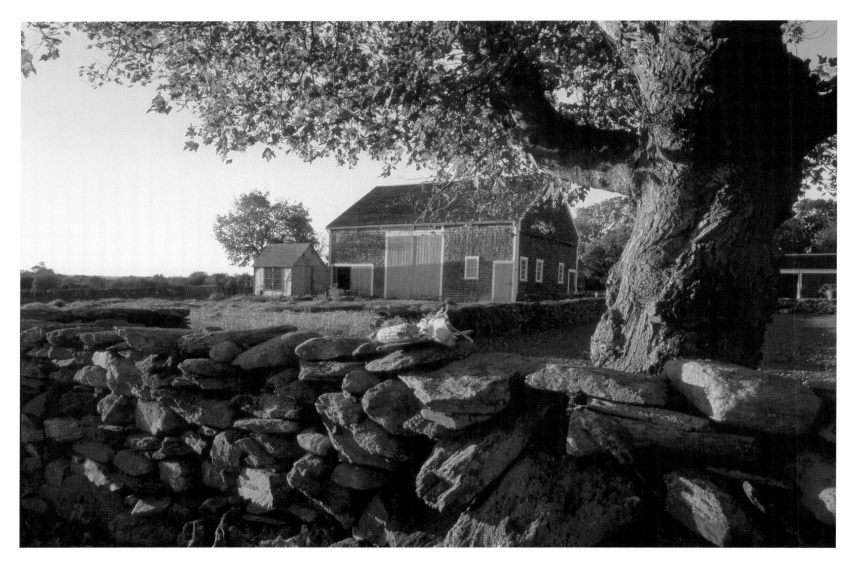

One of the oldest farms in Little Compton

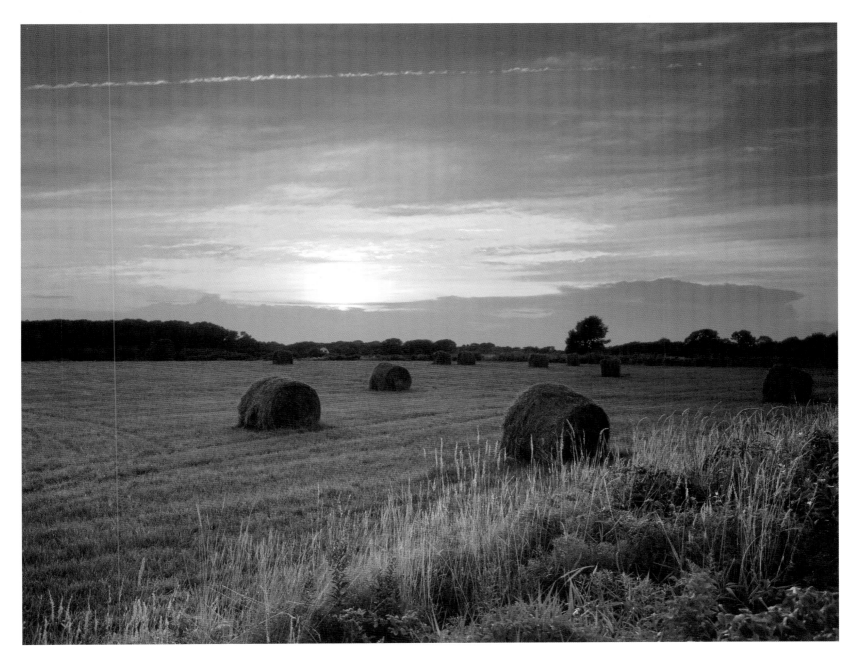

Recently harvested hay, Little Compton

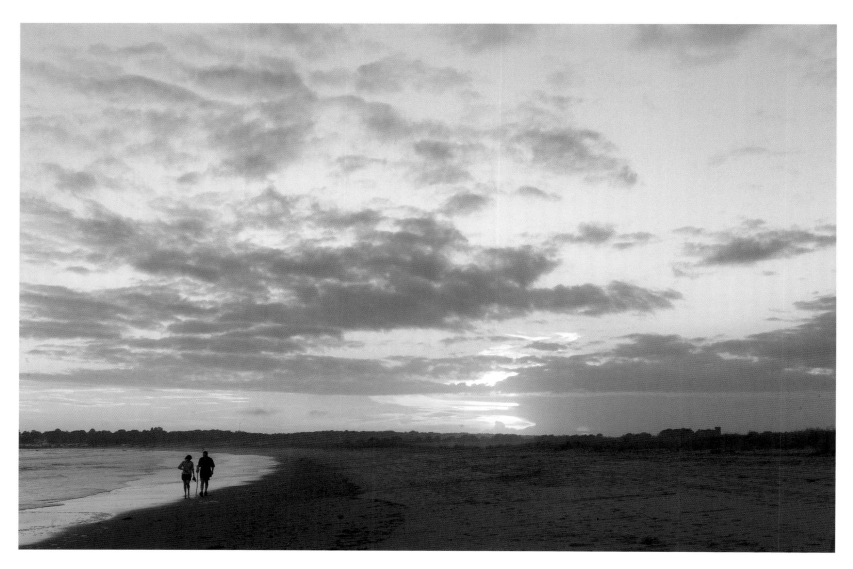

Evening strollers on Goosewing Beach, Little Compton

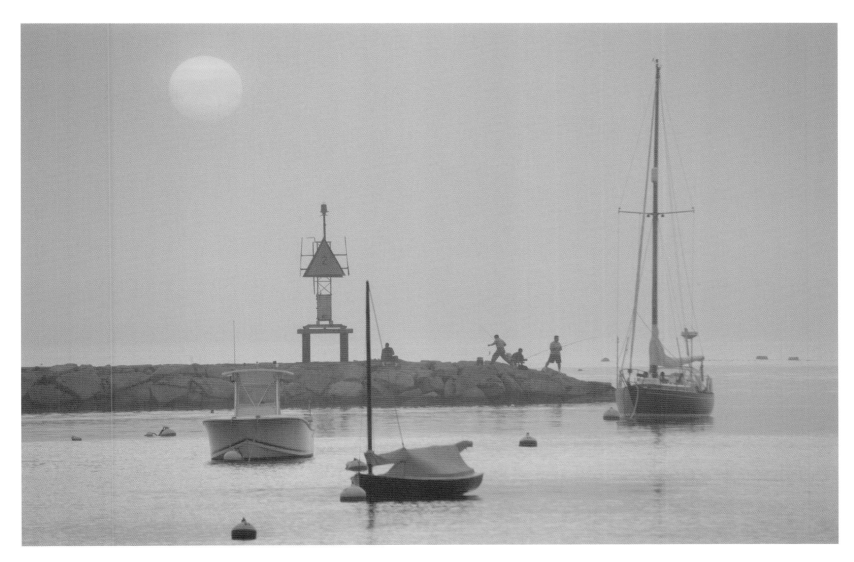

A foggy sunset over the Sakonnet Point breakwater, Little Compton

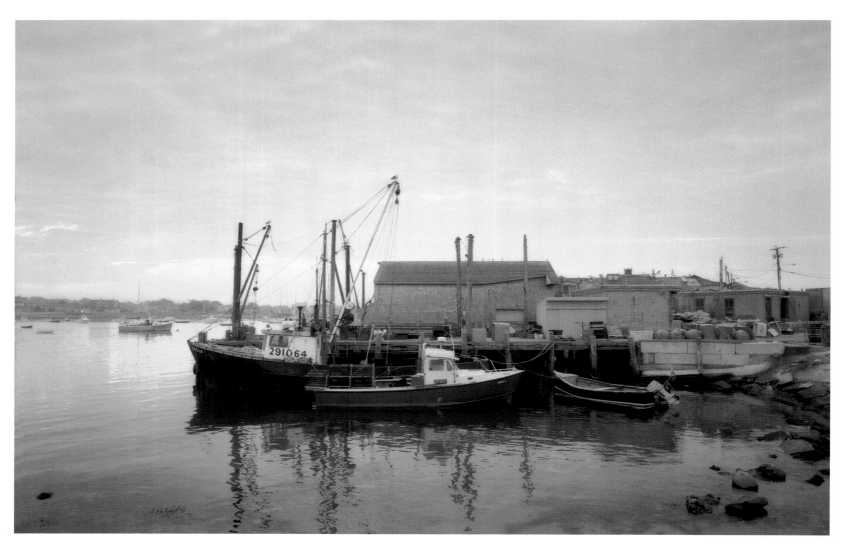

Fishing fleet at Sakonnet Point, Little Compton

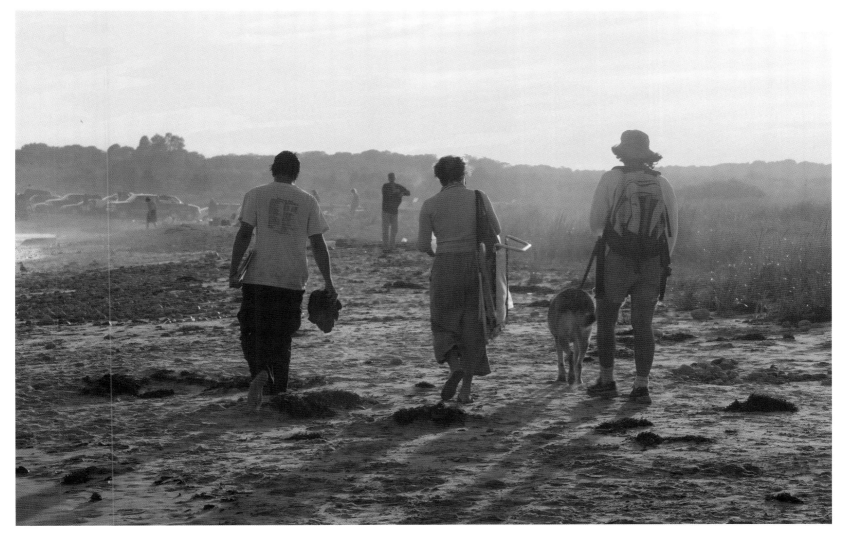

Heading back to the car after a day on Goosewing Beach, Little Compton

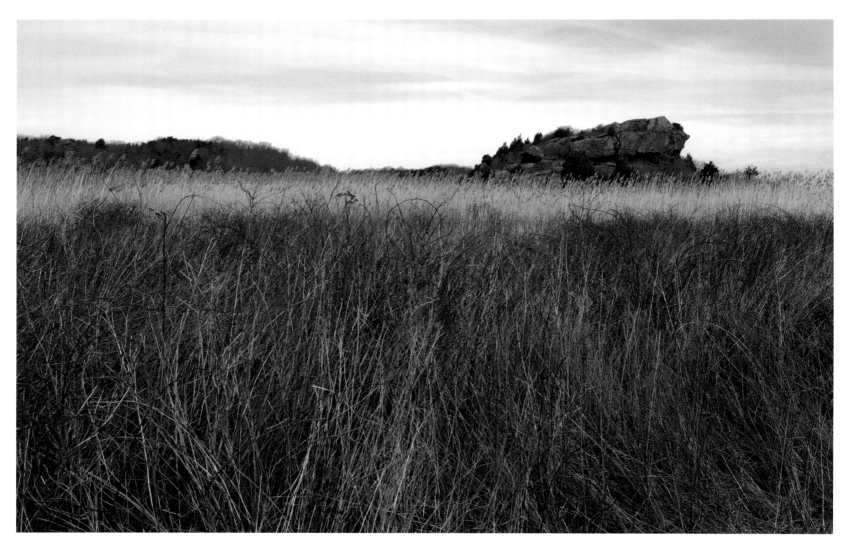

Hanging Rock in Middletown, a popular motif for nineteenth-century
landscape painters on Aquidneck Island

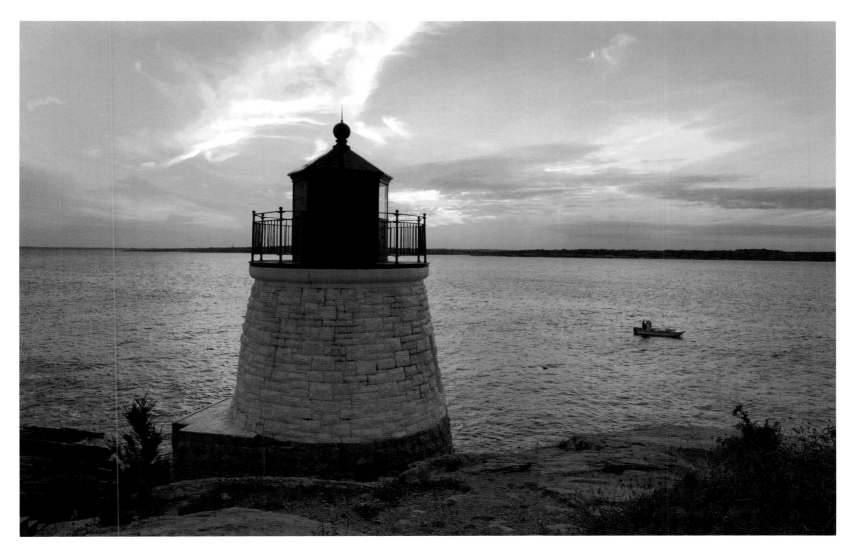

Castle Hill Light looks out over Narragansett Bay. The light, still operational, has guided many a ship into and out of Newport.

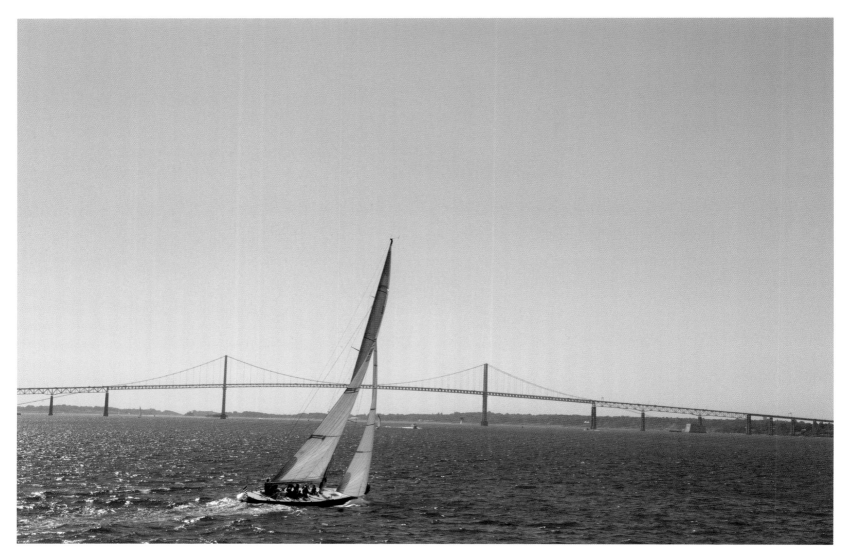

The waters off Newport. On good weekends you can see twelve-meter yachts in these waters.
In the background is the Newport Bridge, with Newport to the left.

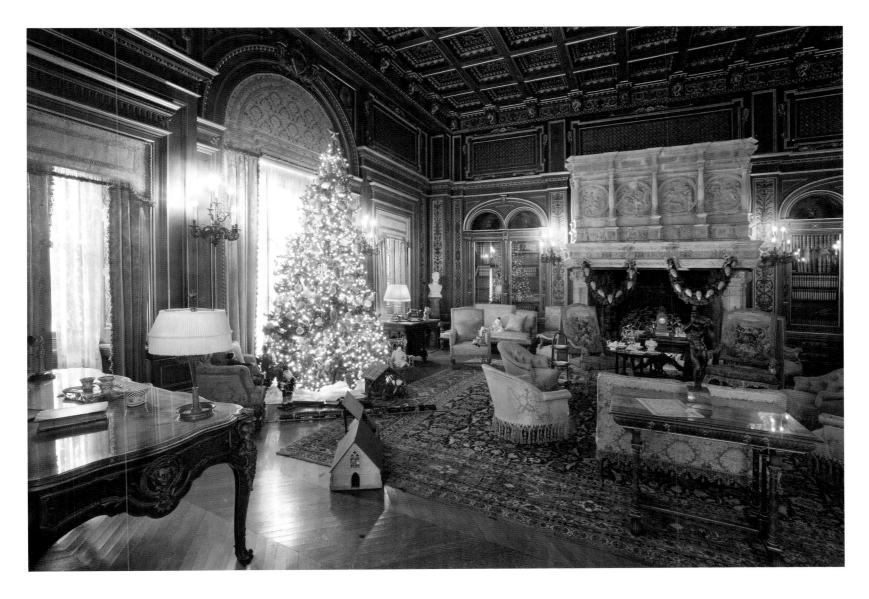

The Breakers, Newport, decorated for Christmas. The Breakers is one of a group of restored mansions maintained by the Preservation Society of Newport County and open to the public.

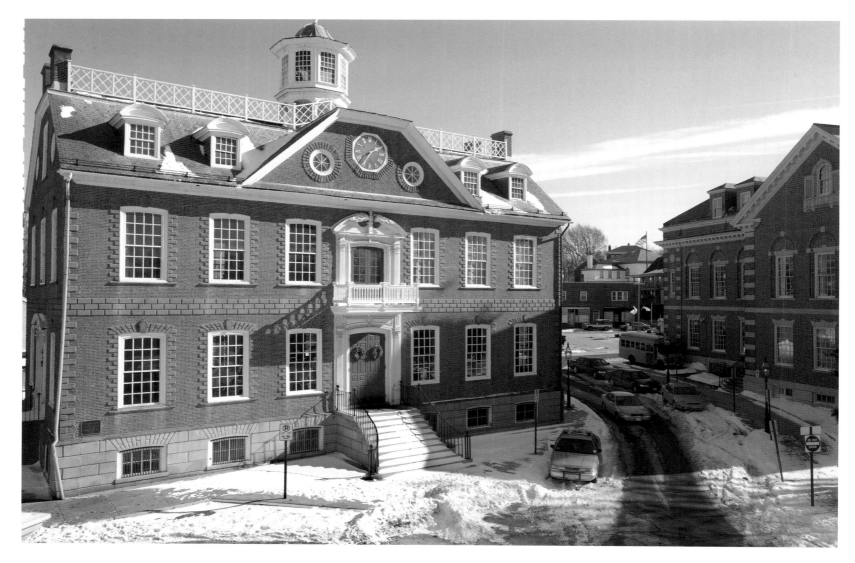

The Colony House on Washington Square in Newport, built in 1739. It was one of a number of regional state houses in operation until 1900, when the present State House was built. The Colony House is maintained and operated by the Newport Historical Society.

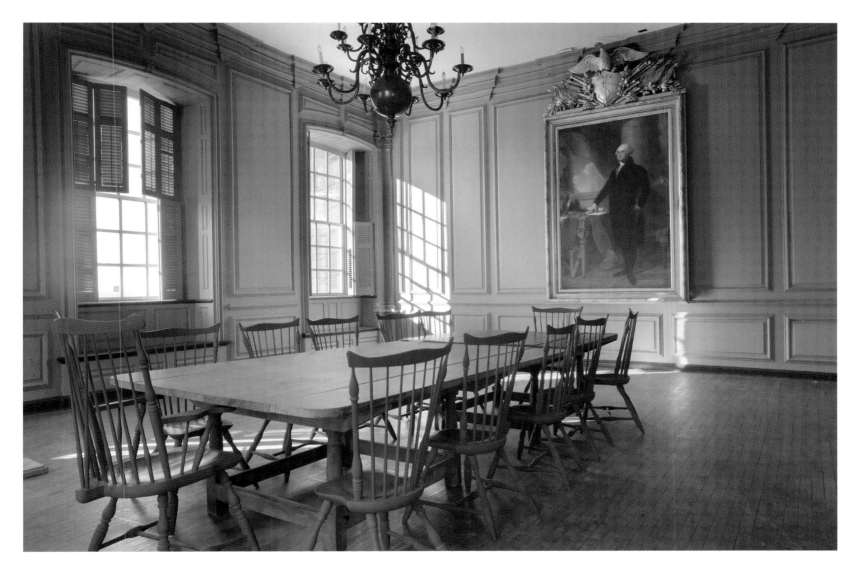

The Governor's Council Chamber in the Colony House. The full-length portrait of George Washington was done by the famous colonial portrait painter Gilbert Stuart, who was born in North Kingstown.

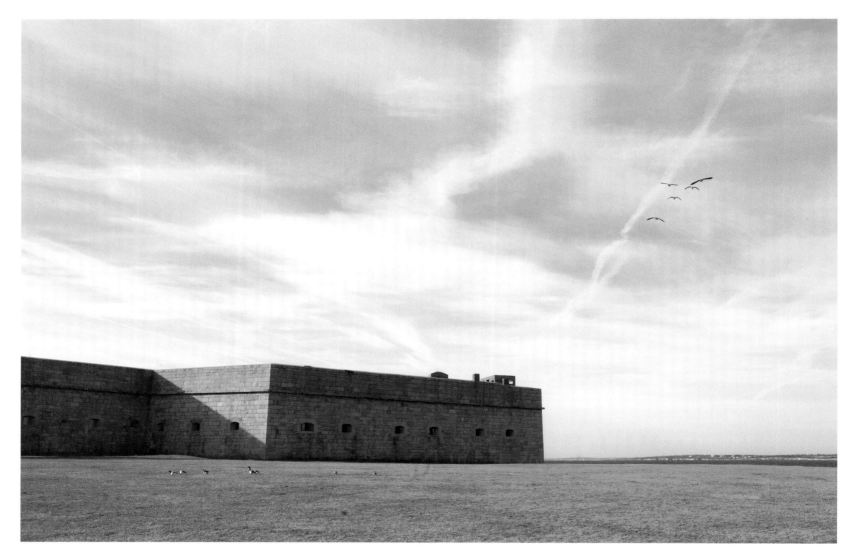

The Civil War–era Fort Adams. Cannons were placed behind the small square windows.
Present-day Newport Jazz Festivals take place on the grassy area.

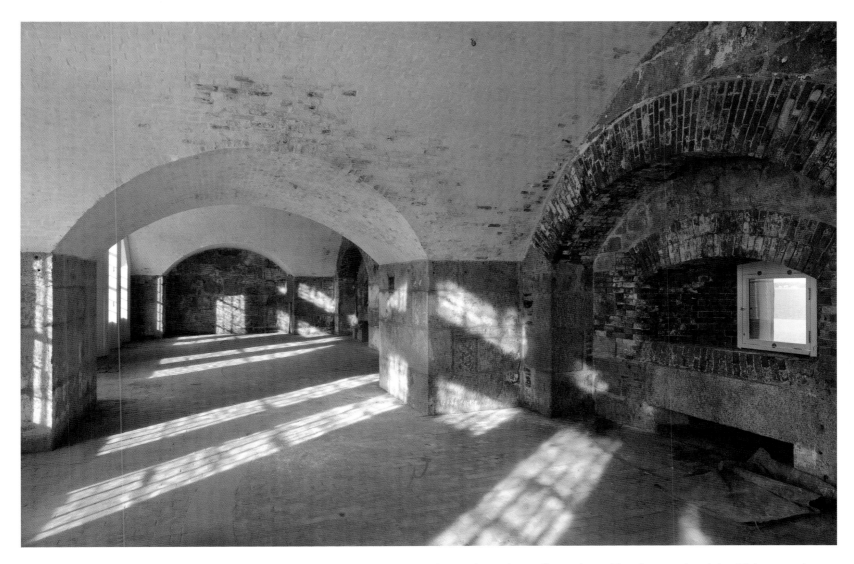

Fort Adams interior. The cannons were located in this arched room, firing through small windows like that on the right. This room has been restored, minus the cannons, and will be used for functions and as a museum.

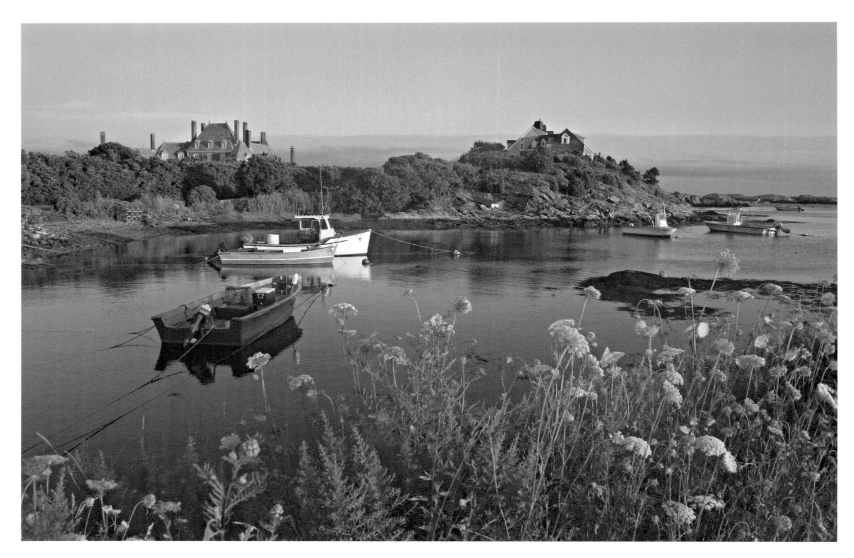

A quiet cove along the Ocean Drive, Newport. Seen behind the working boats in the foreground are two of the many mansions found along the drive.

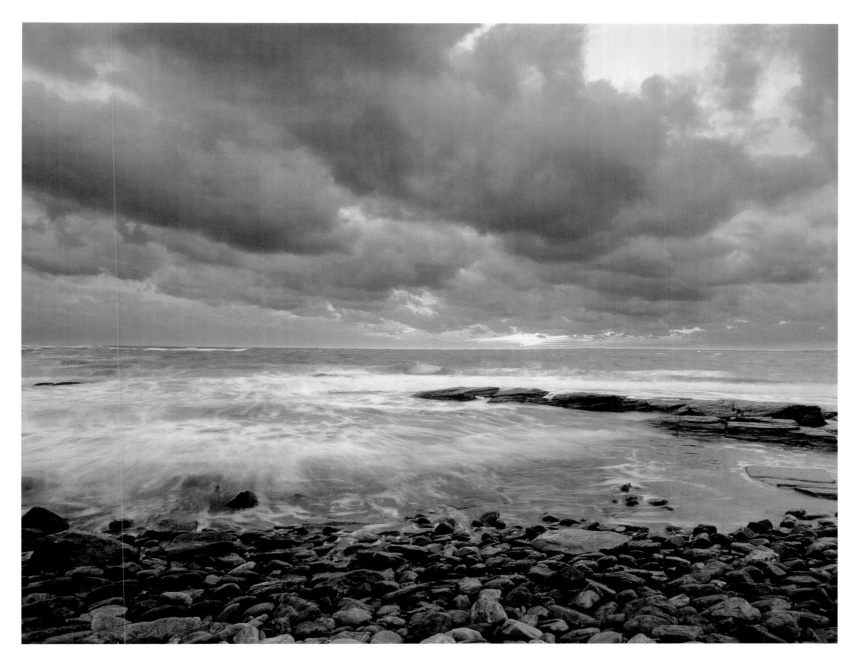

Incoming tide at Brenton Point, along Newport's Ocean Drive. Jamestown is to the south.

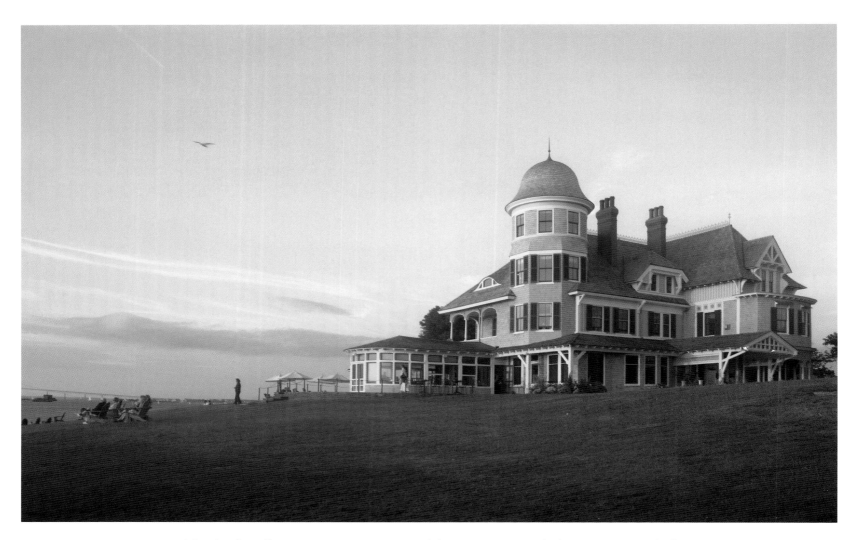

The Castle Hill Inn, Newport. Its views of the ocean—particularly at sunset—and of Newport Bridge to the north make it a popular location for dinners and weddings.

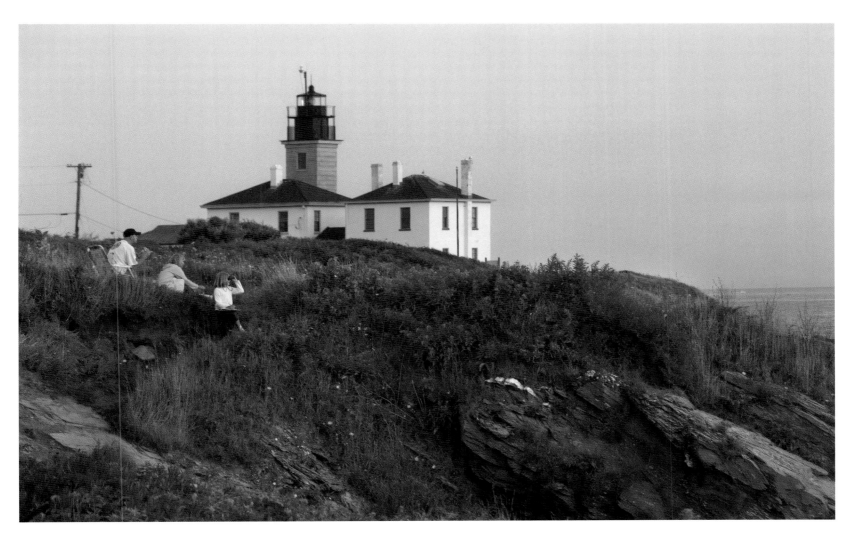

Beavertail Light, Jamestown, a popular destination for evening picnics and sunset watching

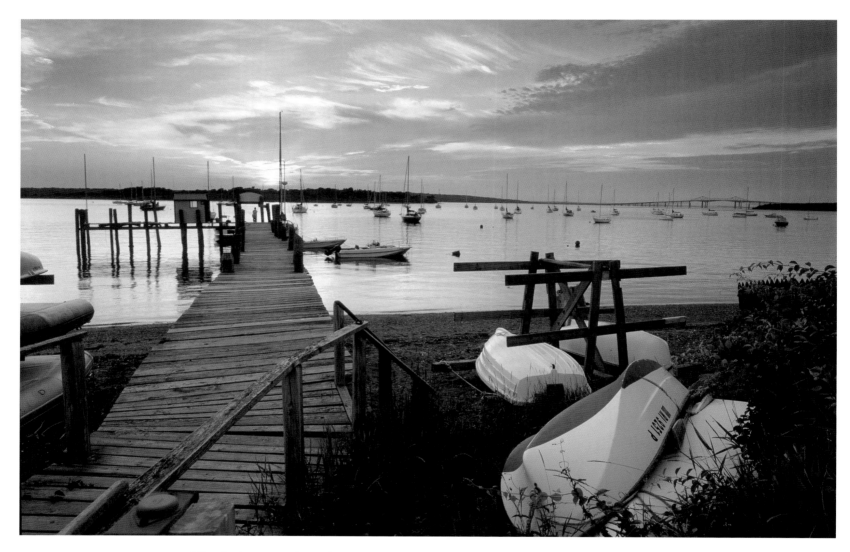

The dock at Dutch Harbor Boatyard, Jamestown, with the old Jamestown bridge
to the right (north) and Dutch Island in the distance.

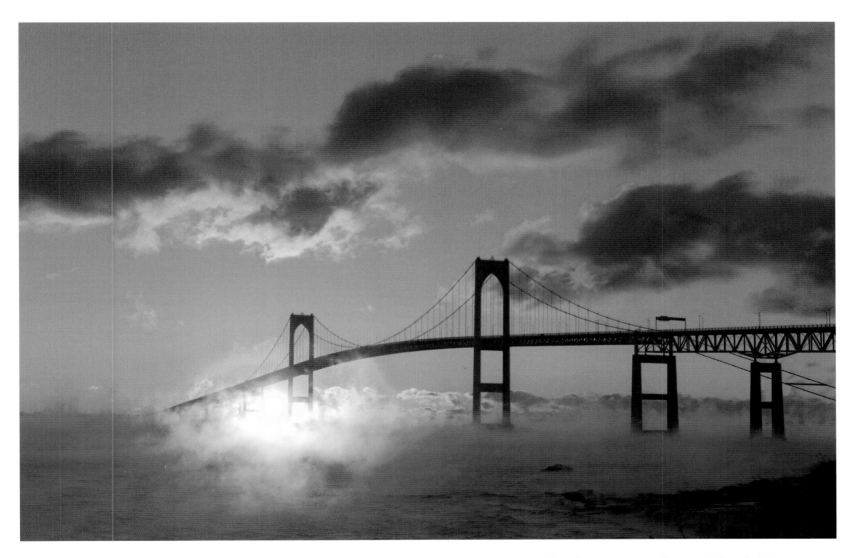

Sunrise beneath the Newport Bridge from Taylor Point, Jamestown, taken on a frigid morning (–4 degrees Fahrenheit) after an unseasonably warm spell. The great temperature difference between the water and the air accounts for the "sea smoke."

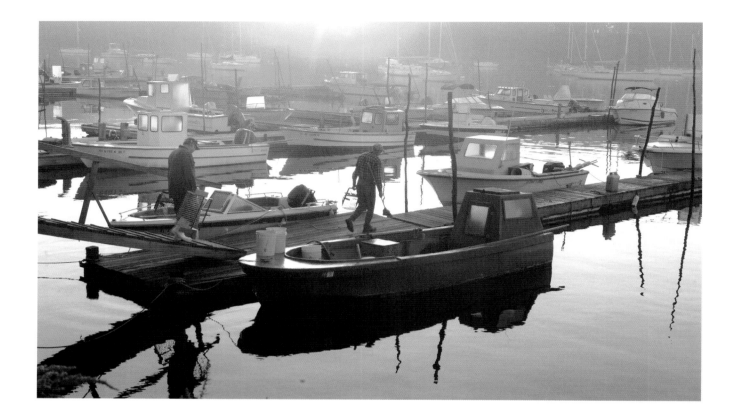

(Above) Shell fishermen heading to their boats while the sun is still low over Greenwich Cove. The quahog is a favorite seafood for Rhode Islanders.

(Left) Dinghies in Greenwich Cove, with Goddard Park across the water

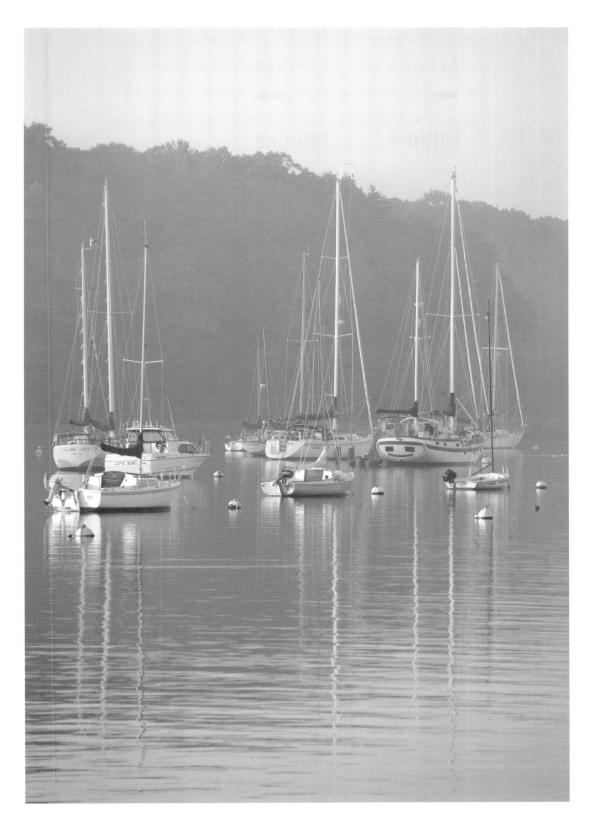

A gentle mist produces soft morning light over the fleet of pleasure boats in Greenwich Cove, quiet before the scramble begins for the open waters of Narragansett Bay.

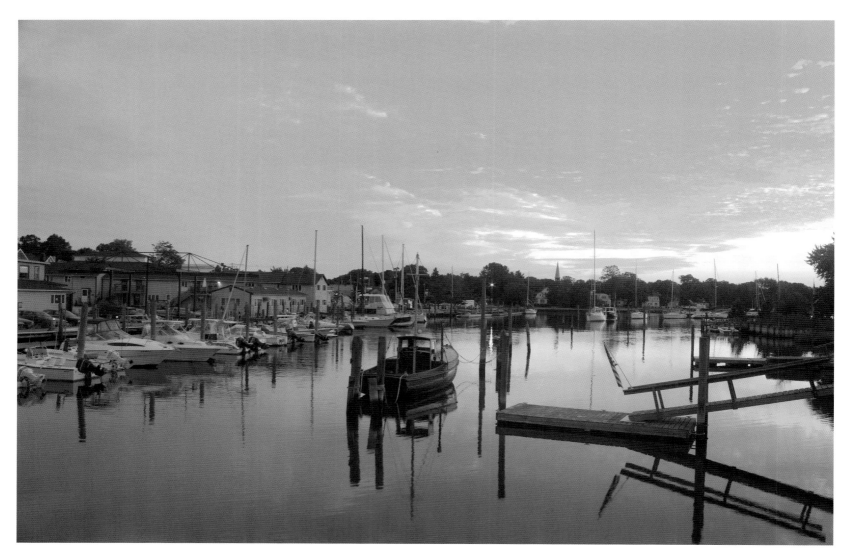

Sunrise over Wickford Harbor

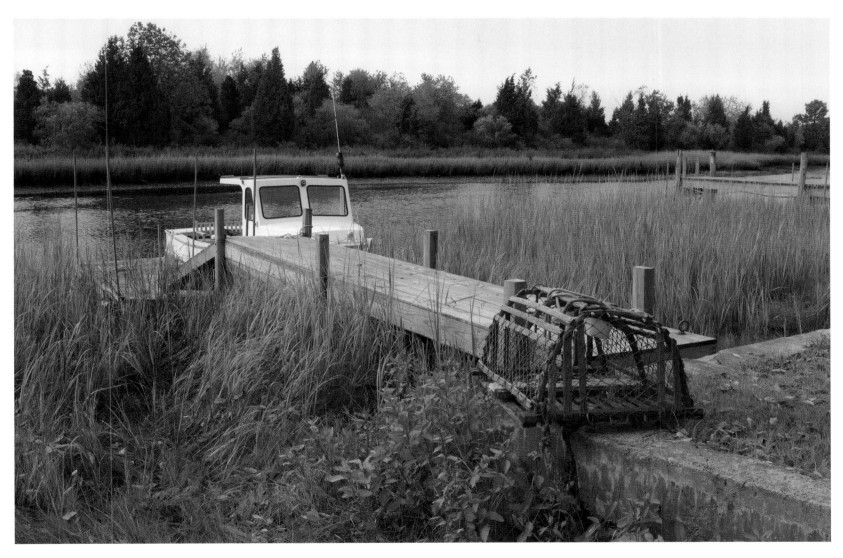

A working boat docked on an inlet off Mill Cove, Wickford

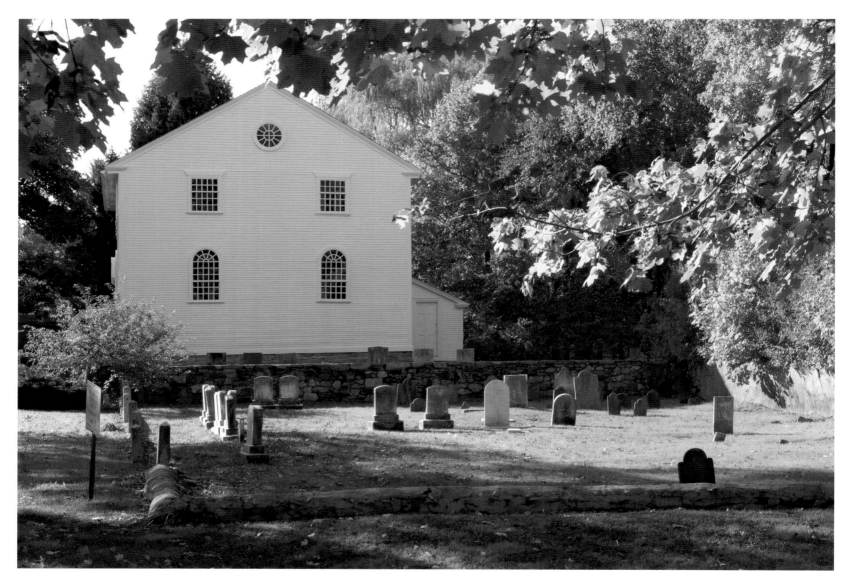

The Old Narragansett Church in Wickford. Built in 1707, it was moved
to its present location on Church Lane in 1800.

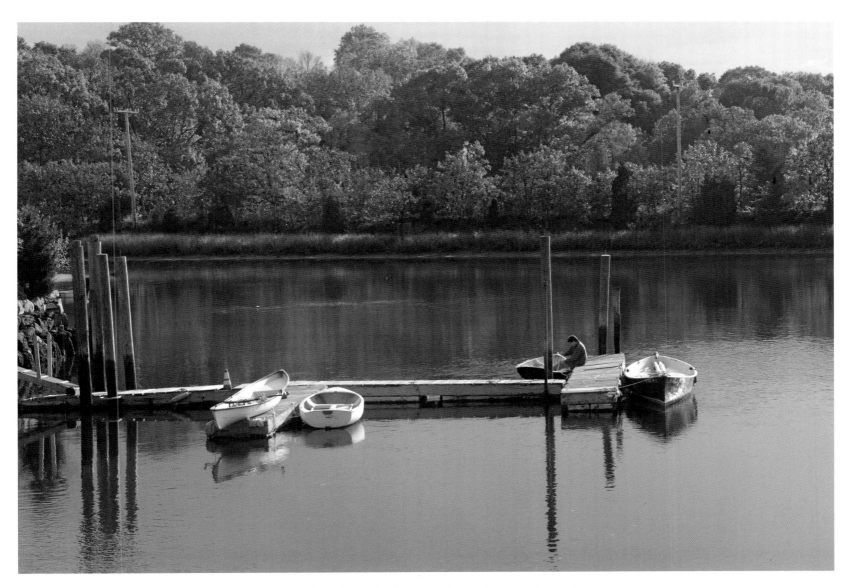

Tom Sgouros of Wickford bails water from his boat after a downpour.

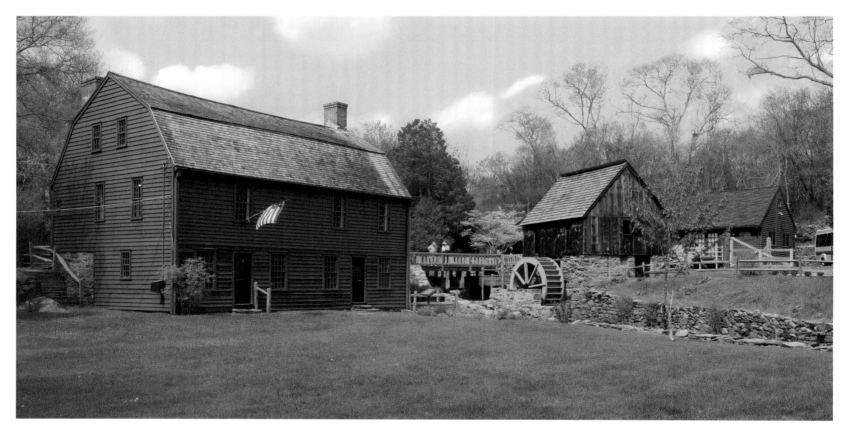

The birthplace of Gilbert Stuart (1755–1828) in North Kingstown. Stuart painted portraits of George Washington, John Adams, Thomas Jefferson, and other famous people of the colonial era. Washington's portrait on the dollar bill is a detail of one of Stuart's paintings.

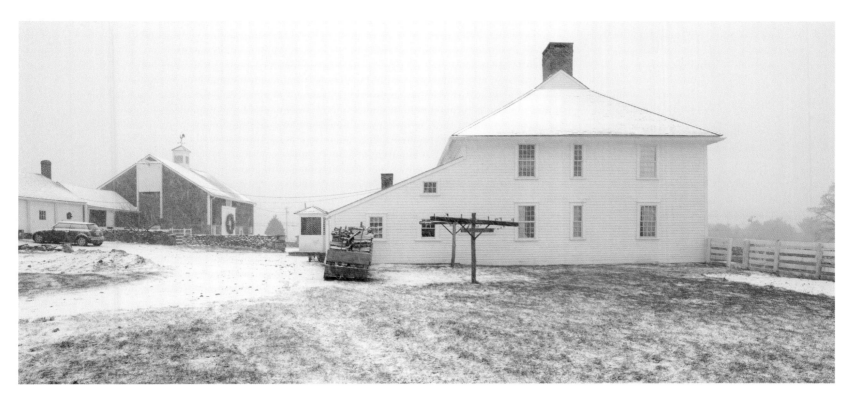

The Casey Farm in Saunderstown, a working farm owned and maintained
by the Society for the Preservation of New England Antiquities

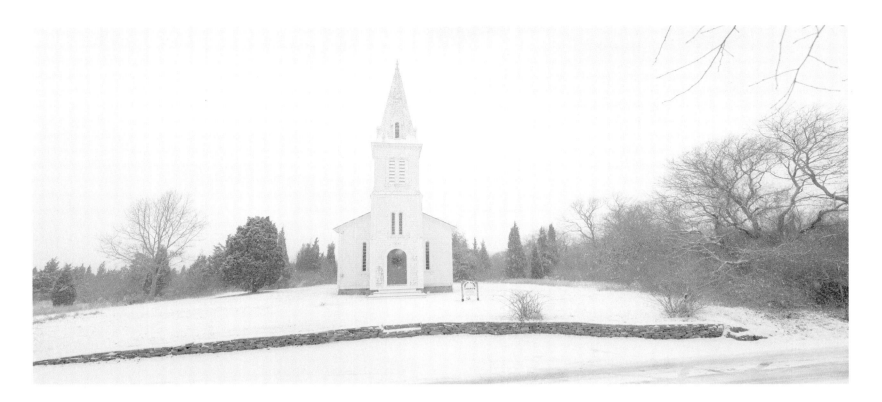

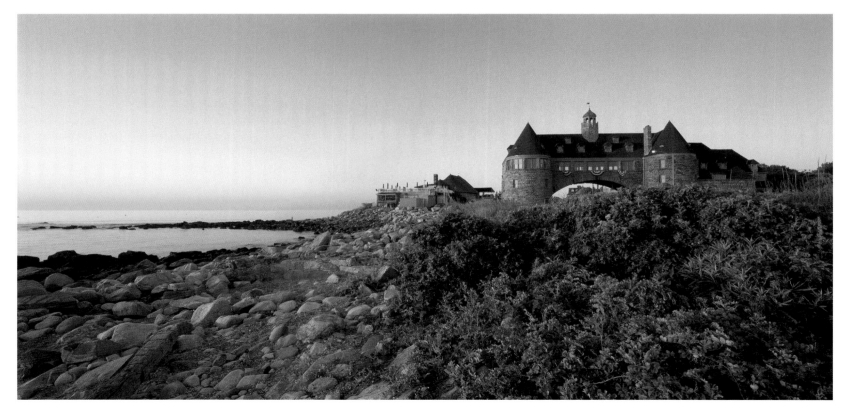

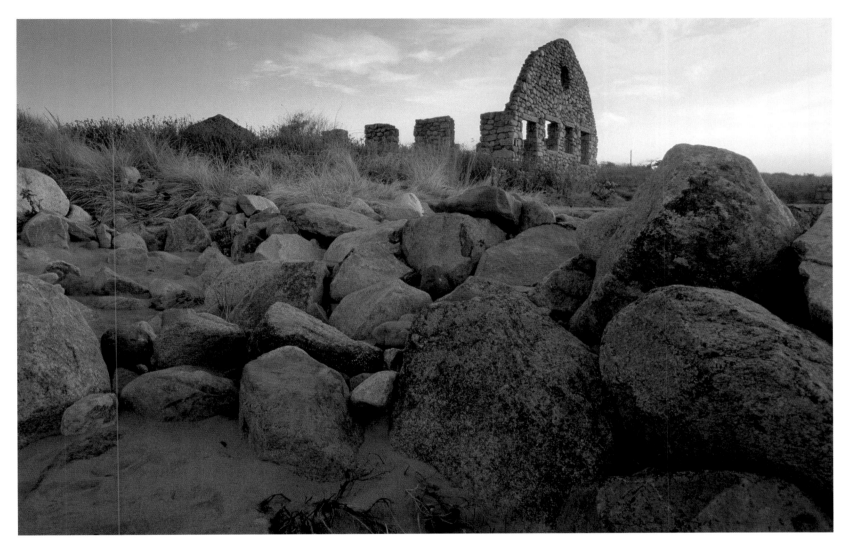

Black Point, Narragansett. This is all that remains of a property that hurricanes have destroyed over the years.

(Left above) South Ferry Church in Narragansett, built between 1850 and 1875. The road in the foreground leads up from the water to the right.

(Left below) The Narragansett Towers was once part of a nineteenth- and early twentieth-century summer colony frequented by New Yorkers. Today the room above the arch is used for functions.

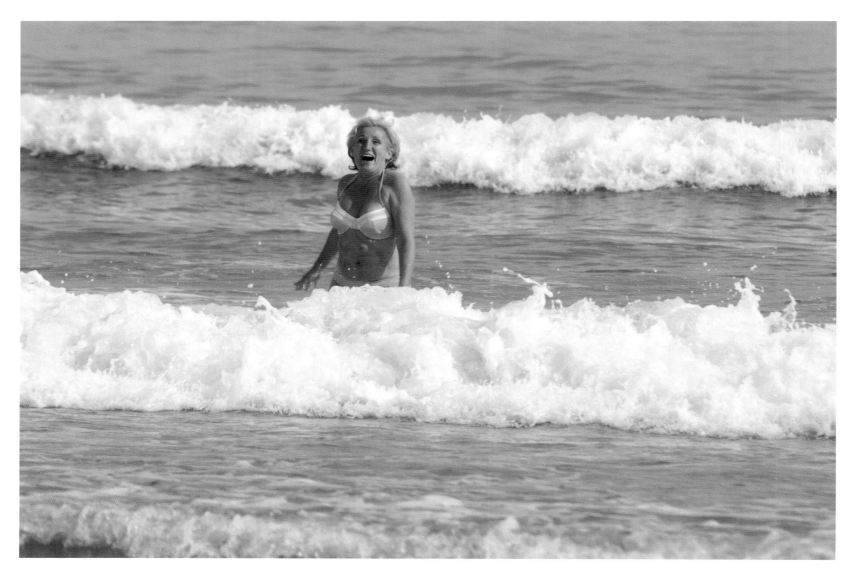

Ingrid Kunz of Zittau, Germany, revels in the surf of Narragansett Beach. Visiting America for the first time,
she wanted to swim in the Atlantic before returning to her village in the former East Germany.
A brief October warm spell gave her that opportunity.

Sunset Farms,
Wakefield

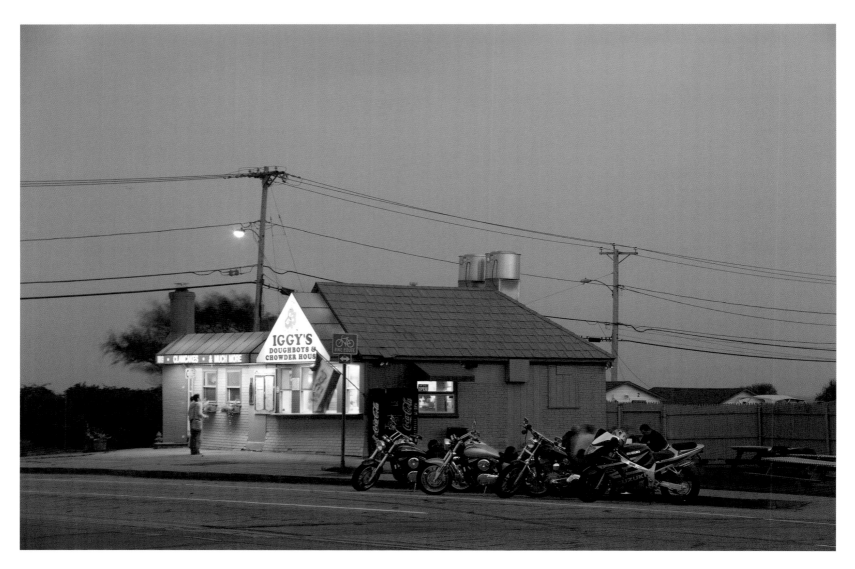

A group of motorcyclists enjoy an October supper at Iggy's in Point Judith while a young lady contemplates the menu. Built in 1924, Iggy's is the oldest beach stand in Rhode Island and has become a landmark. In summer, the line of hungry diners can be very long.

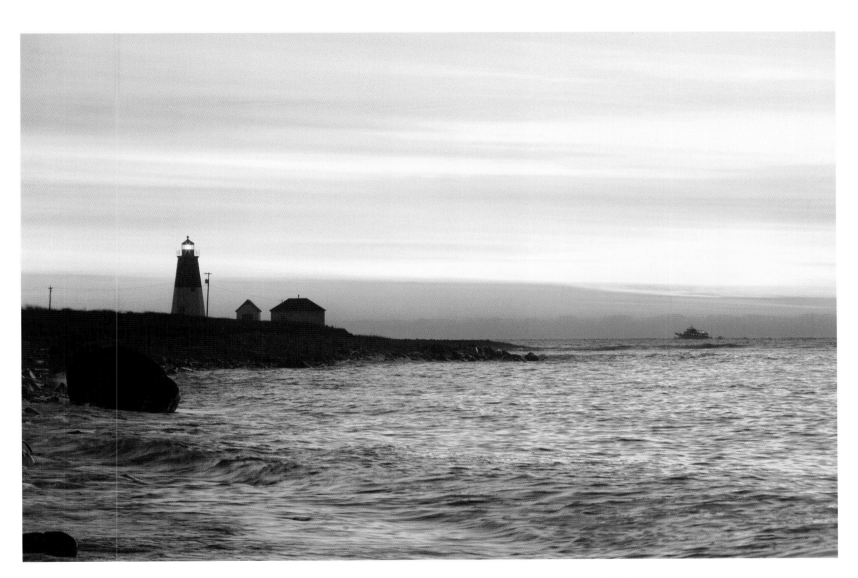

A charter boat makes its way north past Point Judith Light as a new day begins.

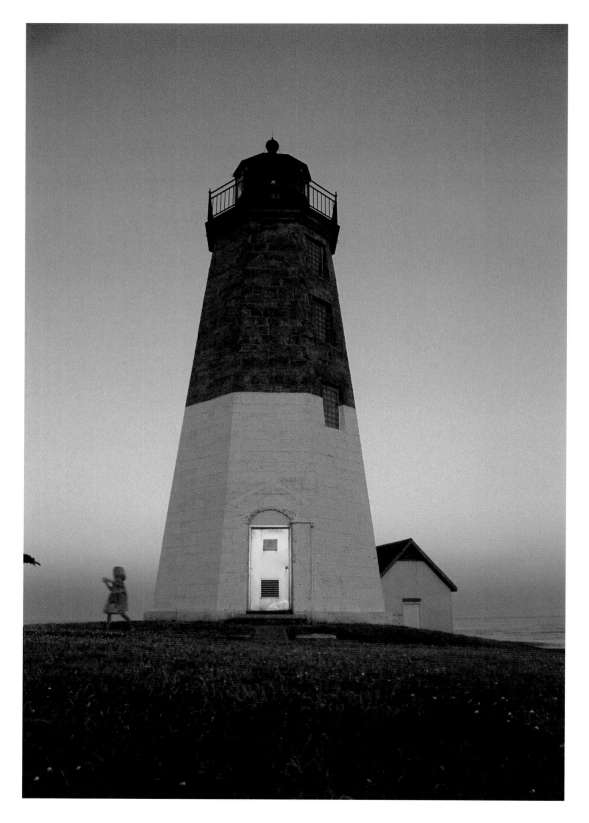

With the setting sun reflecting off the metal door, a child reaches for her mother's outstretched hand, ending an outing to Point Judith Light.

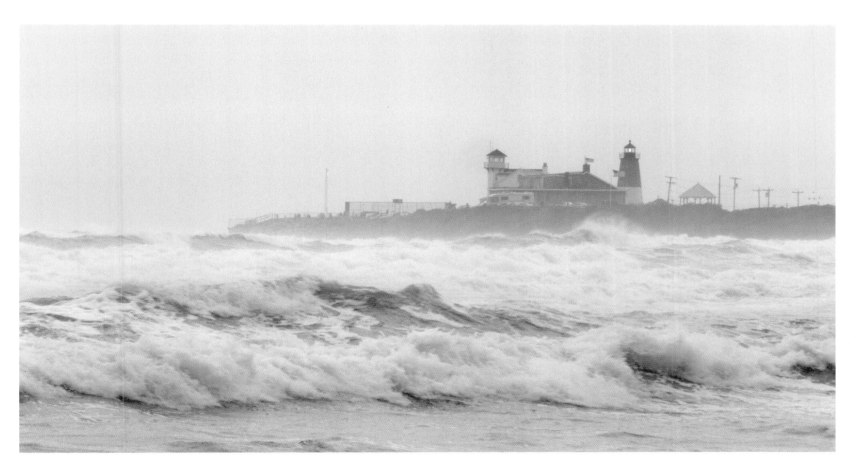

Rough waters off Point Judith as a hurricane passes about a hundred miles to the south

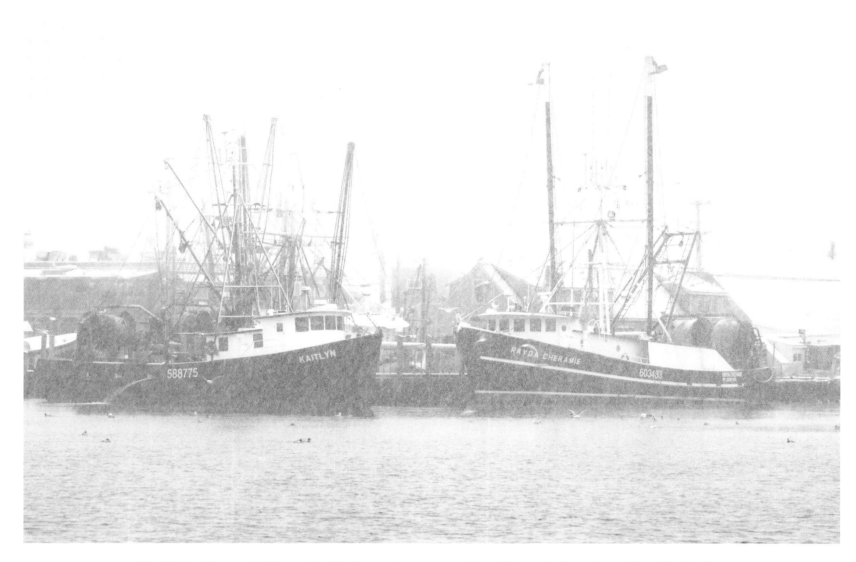

The fishing fleet at Galilee socked in by a winter storm, viewed from the Jerusalem side of the harbor.

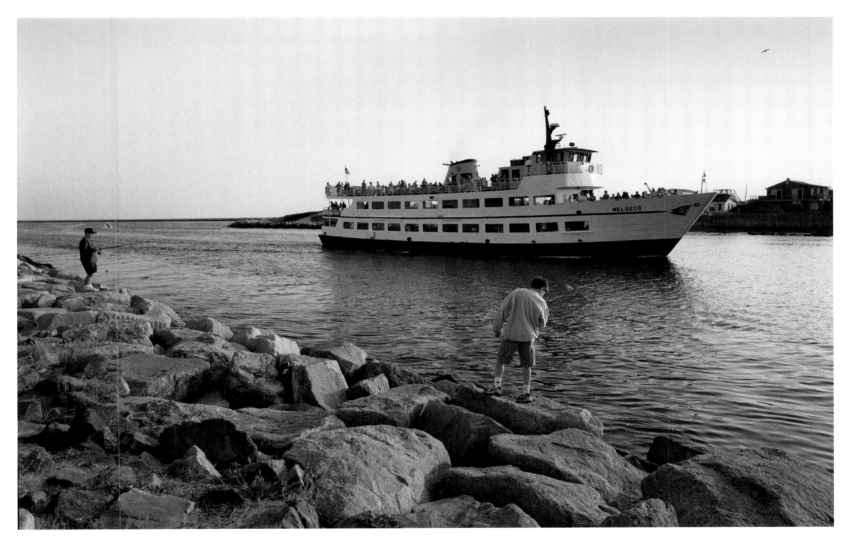

The Block Island Ferry returns, passing two boys fishing on the Galilee side of the harbor.

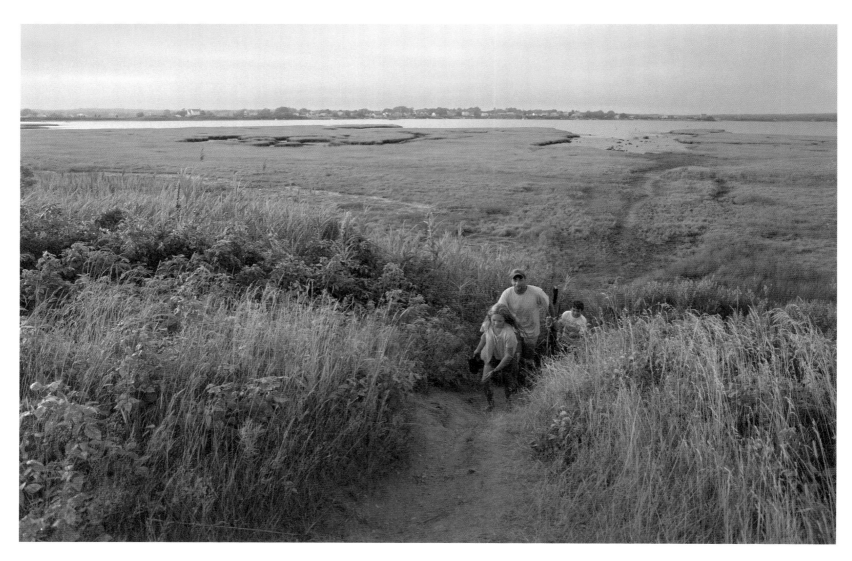

A family heads back to their car on the Galilee Escape Road after digging for quahogs
in the mudflats of Bluff Hill Cove (background).

A lone seagull occupies the parking lot of Salty Brine State Beach in Galilee.

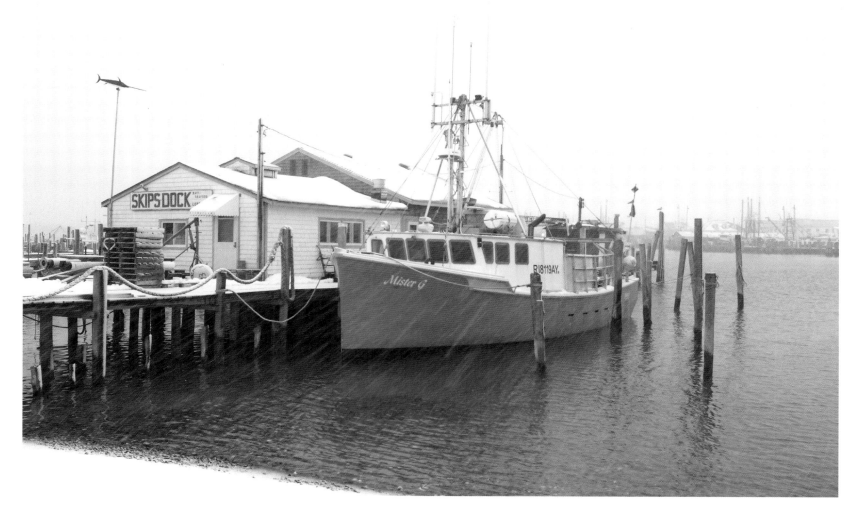

Skip's Dock, Jerusalem, with the Galilee fishing fleet across the water

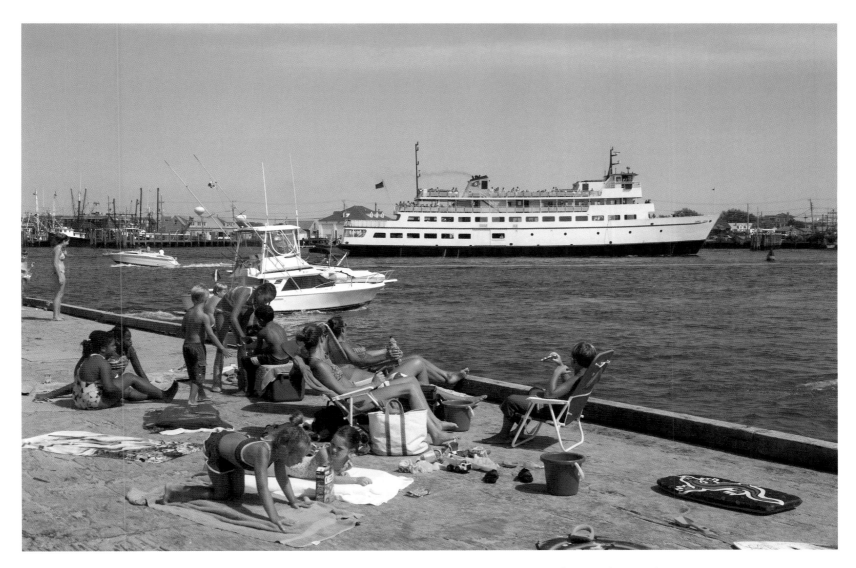

The Block Island Ferry heads out from Galilee past a group of sun-seekers and
boaters, as seen from the Jerusalem side of the harbor.

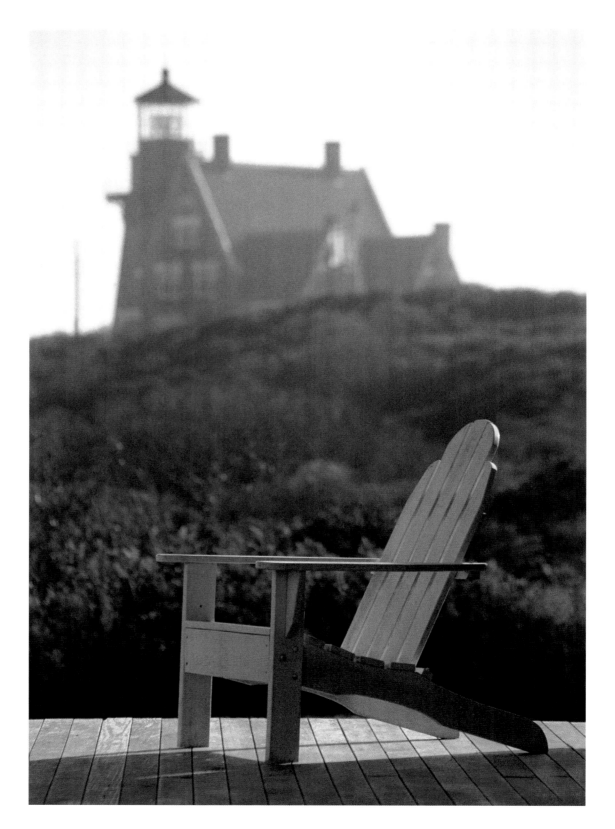

Southeast Light, Block Island. The lighthouse was moved away from a gradually eroding cliff after this photo was taken in the mid-1980s.

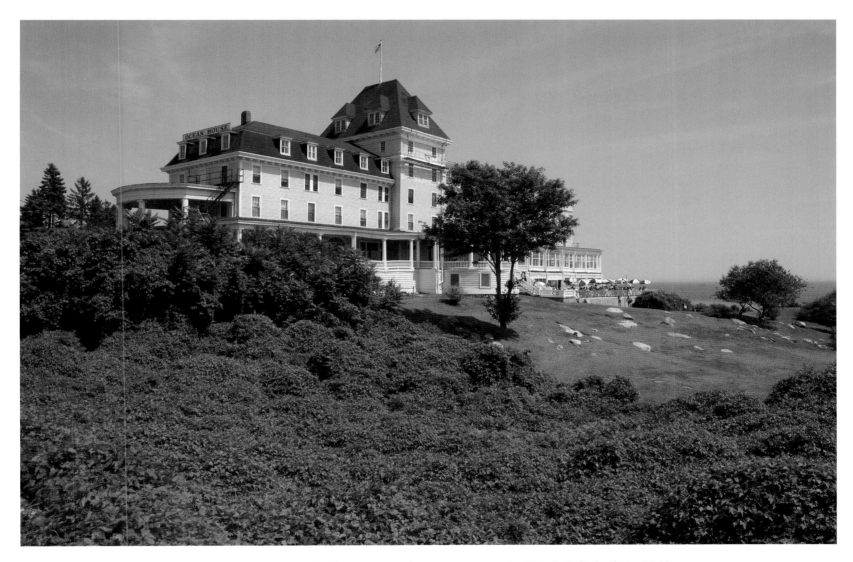

One of the grand hotels of a past era: the Ocean House in Watch Hill, built in 1868.
The land in the foreground was once part of a small golf course.
As of this writing, the hotel has been sold and is slated for demolition.

The Flying Horse Carousel, said to be the oldest operating merry-go-round in the country.
Brought to Watch Hill in 1879, it has twenty ponies suspended by chains.

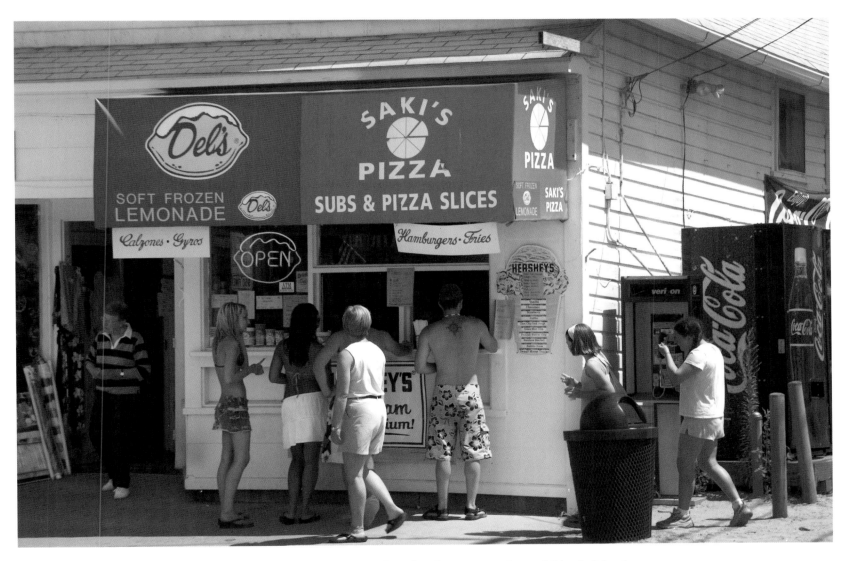

Summer on Bay Street in Watch Hill, where generations of Rhode Islanders
have enjoyed Del's Frozen Lemonade

BACK ROADS

Much awaits the curious explorer of the back roads and woods of "Little Rhody." Old mills recall a rich industrial history—indeed, Slater Mill in Pawtucket is said to be the birthplace of the American Industrial Revolution. In small towns away from the malls, the explorer will find mom-and-pop stores and reasonably priced neighborhood diners; fine old farmhouses and barns and grazing cattle; and, in the fall, good food and bargains at local "autumn fests."

Hope Valley Pub, a sports bar in Hopkinton

(Right) A convenience store on Main Street in Hopkinton

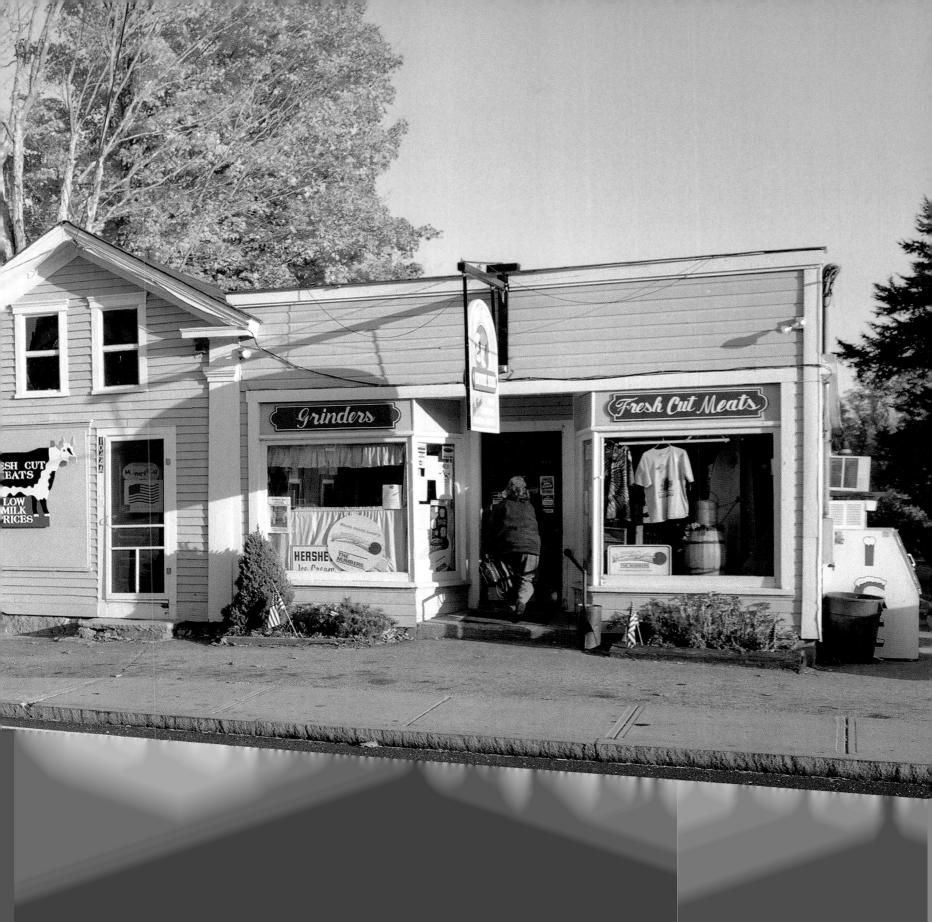

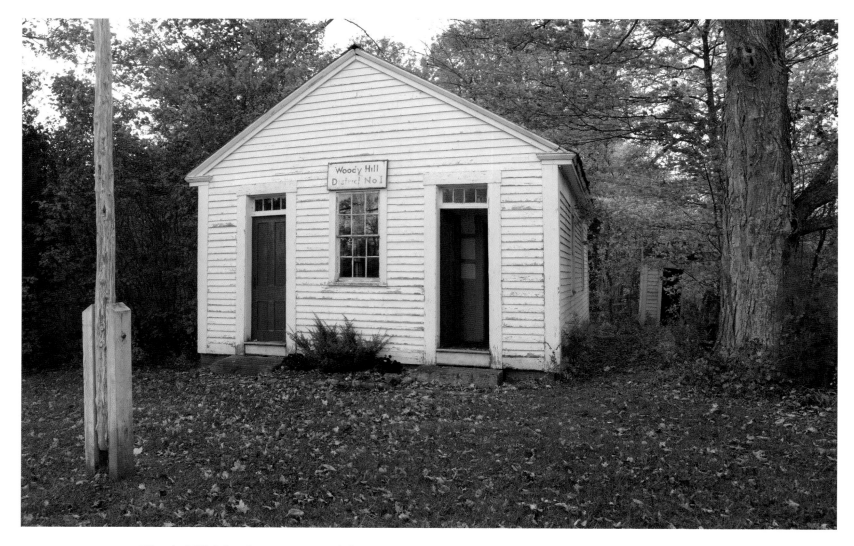

Woody Hill School, Exeter. Out of the way on a back road, the school harks back to simpler times.
Used between 1851 and 1942, it was restored around 1976, but roof leaks have caused the floor to rot down
to the sills. Behind the building are two outhouses, labeled BOYS and GIRLS.

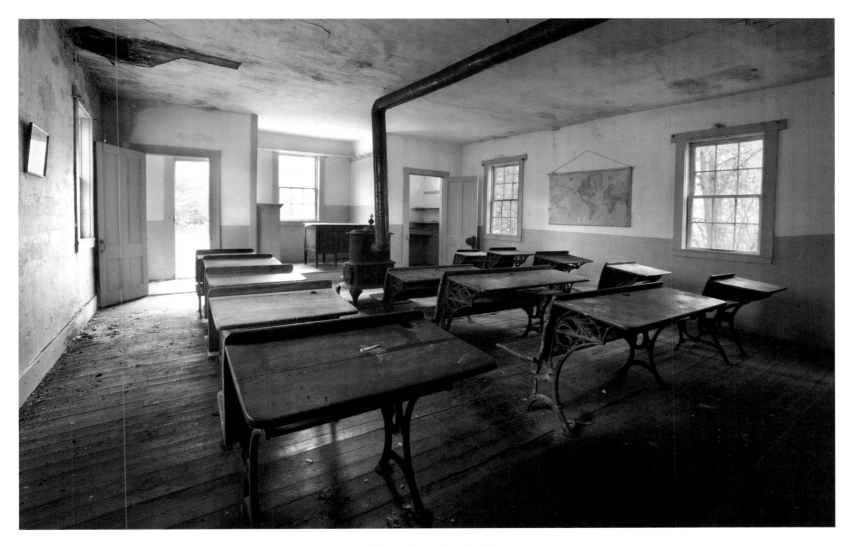

Interior of Woody Hill School, Exeter.

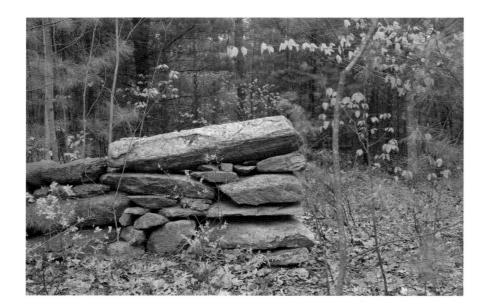

(Left) A stone wall in Exeter offers a clue that the wooded land was once cleared for farming and grazing.

(Below) Bates Schoolhouse Road in Exeter is one of the many remaining unpaved roads in rural Rhode Island. Most, like this one, are well maintained

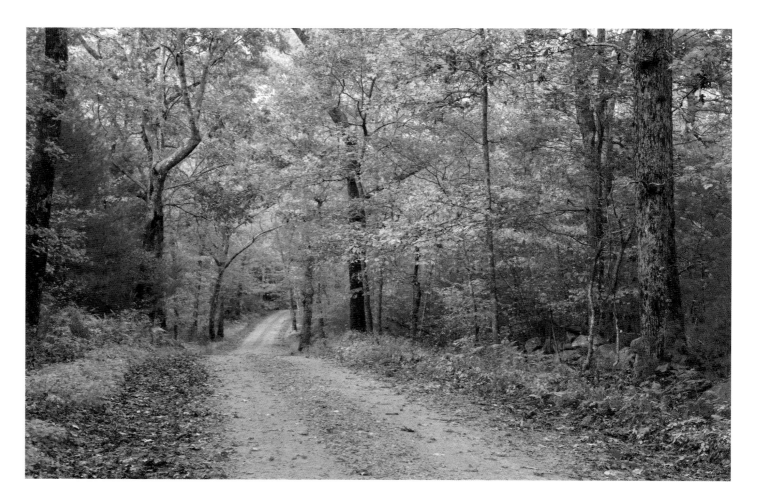

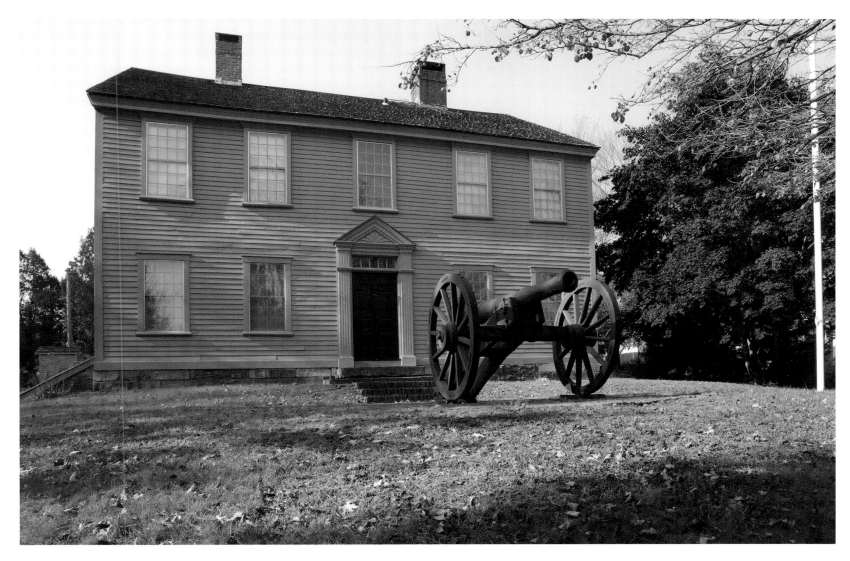

The Coventry home of Revolutionary War general Nathaniel Greene

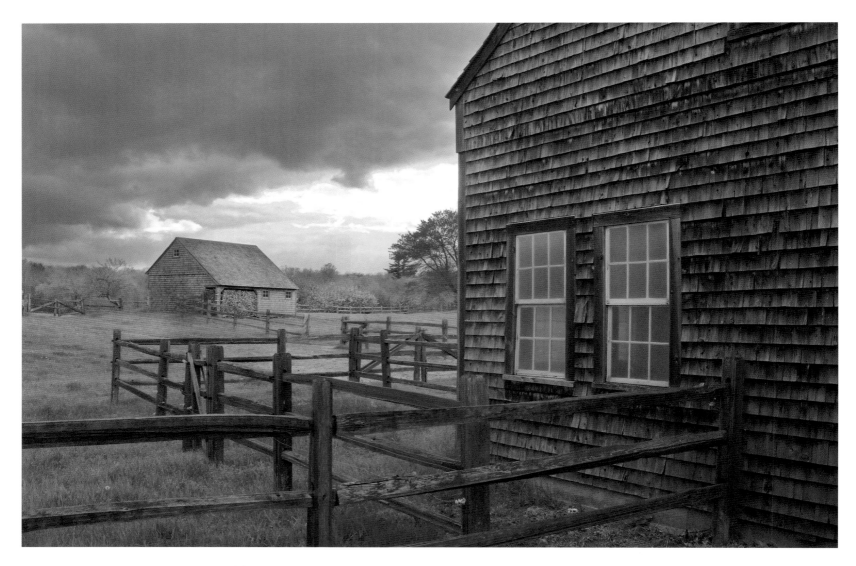

A woodshed and barn on Walker Road in Foster, with a spring storm approaching

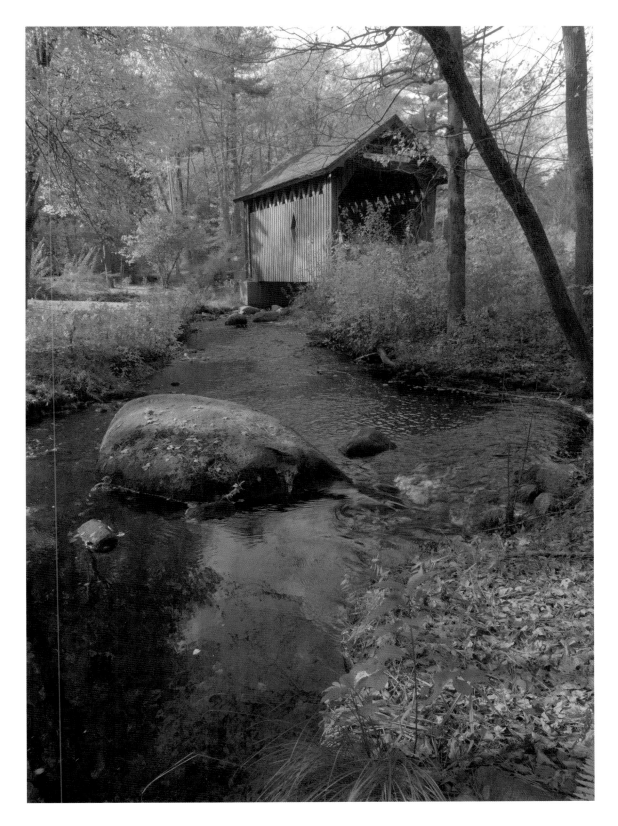

Swamp Meadow
Covered Bridge on
Central Pike, Foster,
the state's only covered
bridge. The bridge was
built in 1994 to replace
an earlier bridge that
was destroyed by arson.

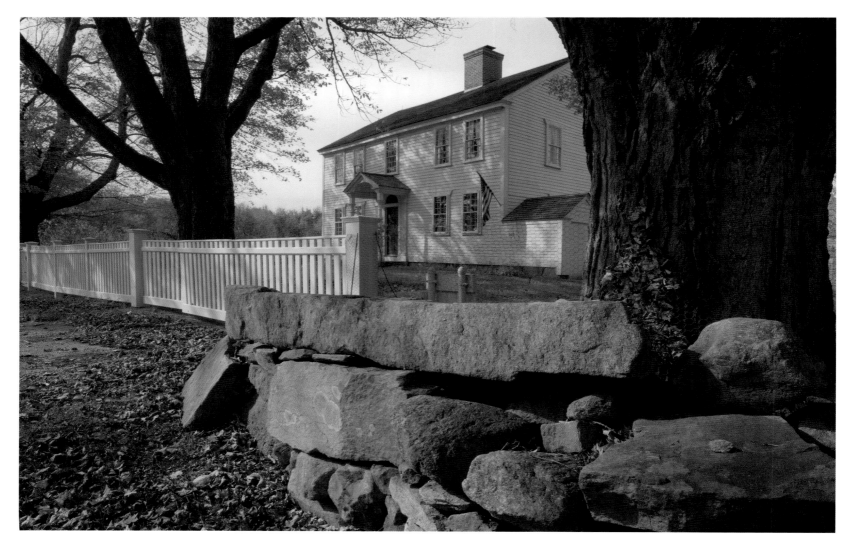

A restored house, Foster

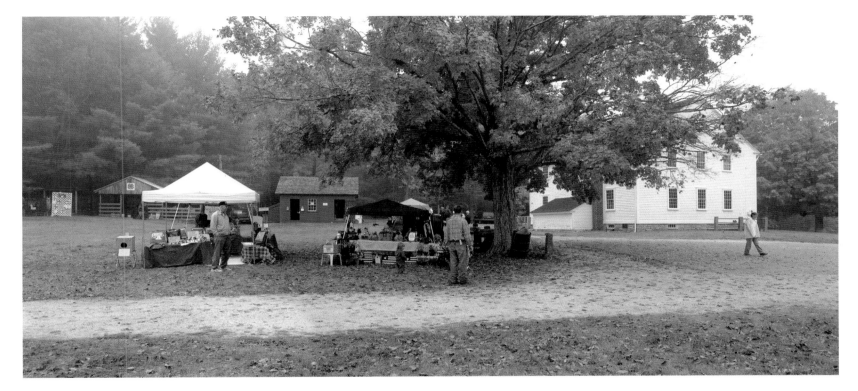

Setting up for the annual Autumn Fest on the grounds behind the Foster Town House, seen at right.
Built in 1796, it is said to be the oldest town house in the nation still used for town meetings.

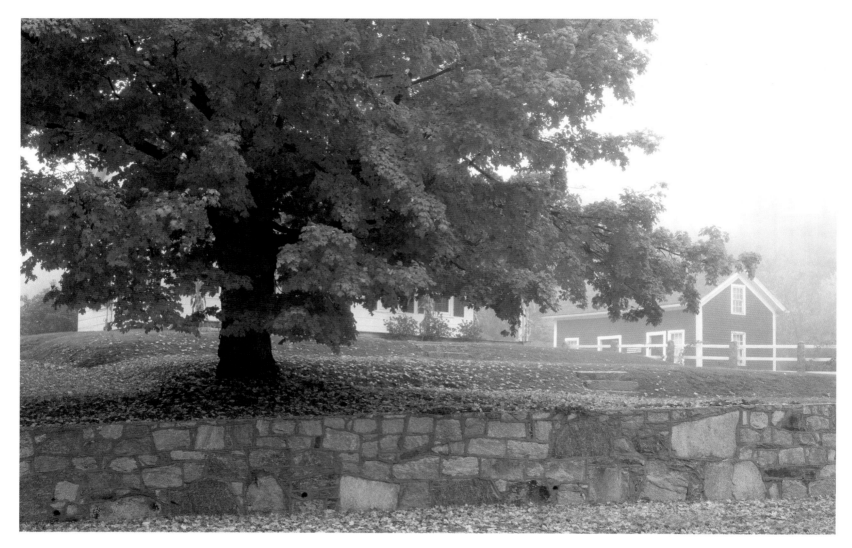

Misty autumn colors along Victory Highway in Burrillville

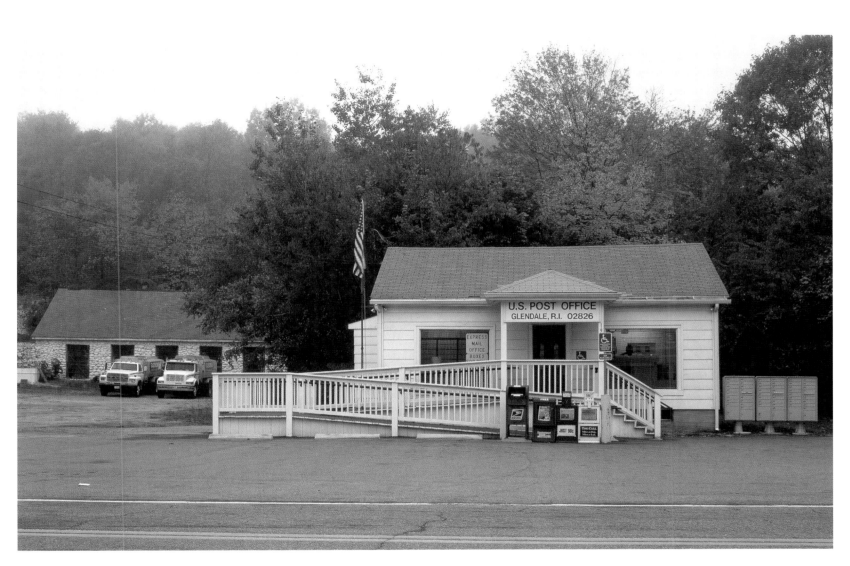

Post office, Glendale section of Burrillville

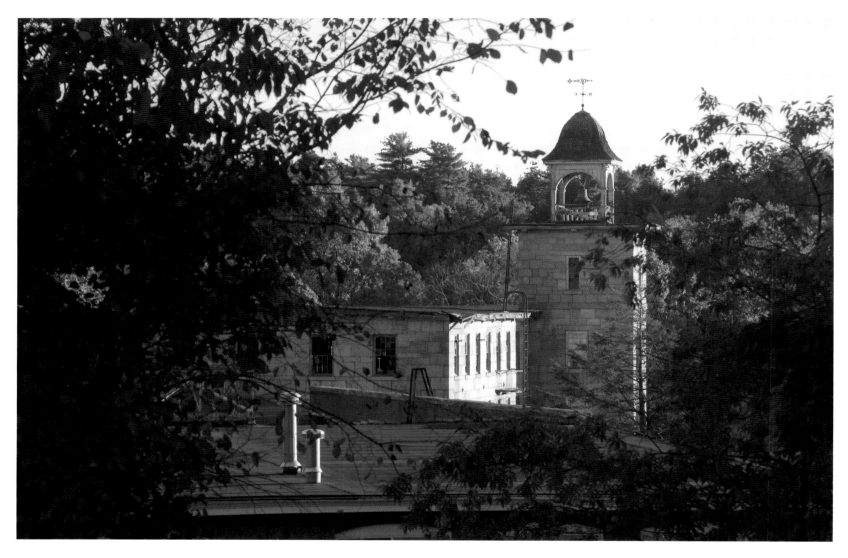

An old mill in the Slatersville section of North Smithfield, one of many found throughout the state

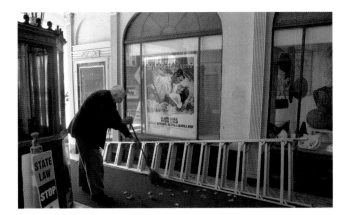

(*Right*) Roger Petit, a volunteer for the Stadium Theatre Foundation in Woonsocket, sweeps the lobby beneath an original French-language poster for *Gone with the Wind*. The city is known for its French Canadian heritage.

(*Below*) An exterior view of the theater. Built in 1926, it was restored in the 1990s and now has an active calendar of events.

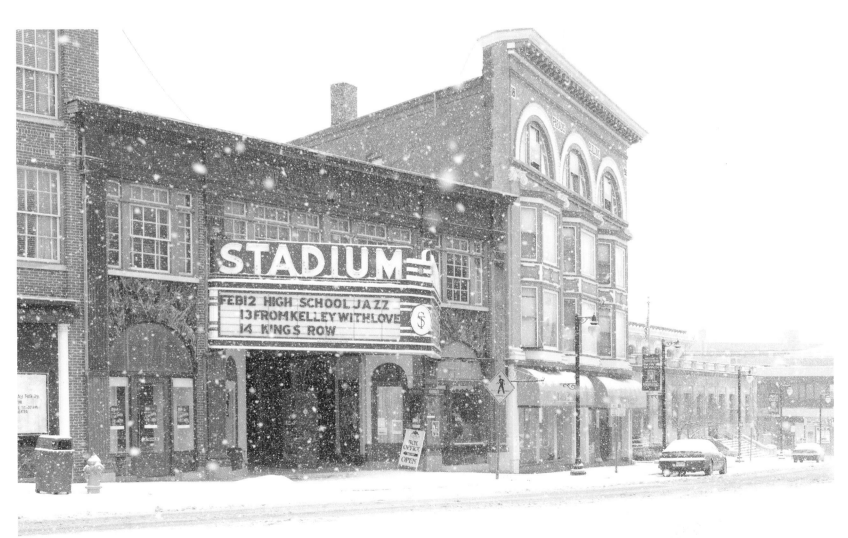

The Blackstone River, passing
through the Manville section
of Cumberland

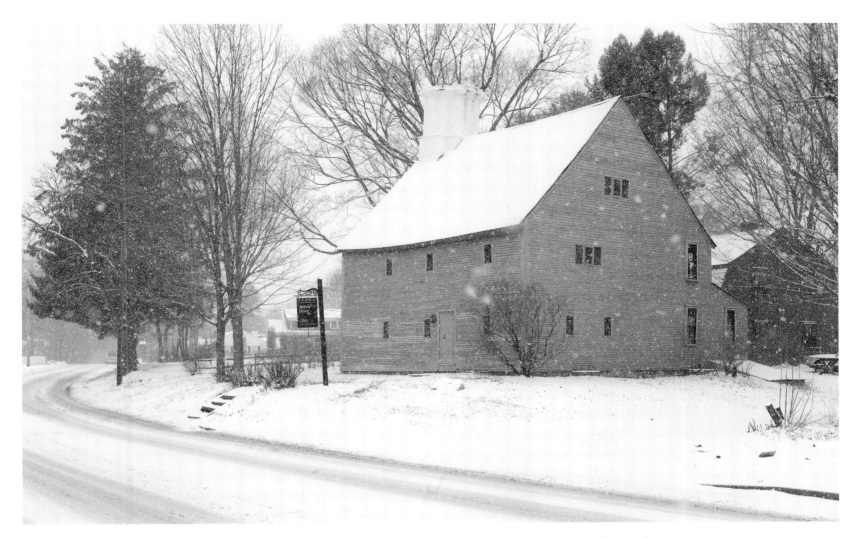

The Eleazer Arnold House on Great Road, Lincoln. The chimney structure takes up almost the entire west wall, making the house a good example of a Rhode Island "stone ender." It is owned and maintained by the Society for the Preservation of New England Antiquities.

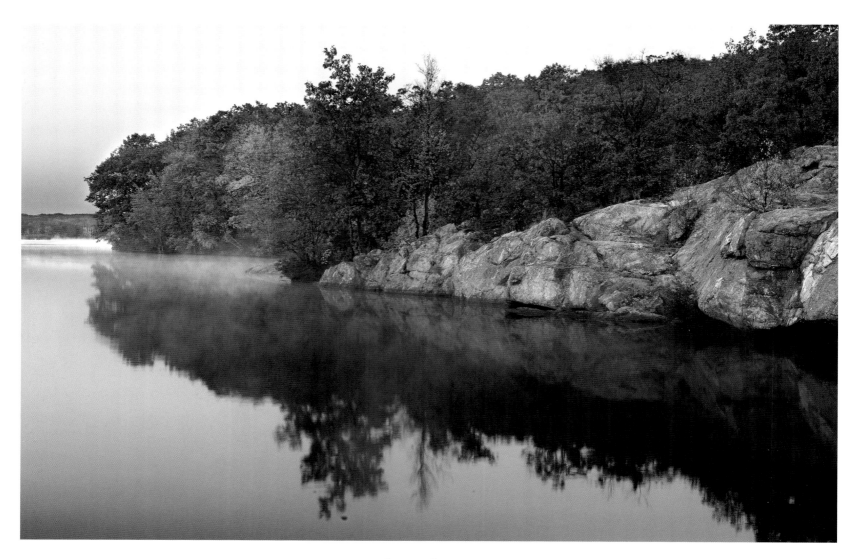

Lincoln Woods in autumn

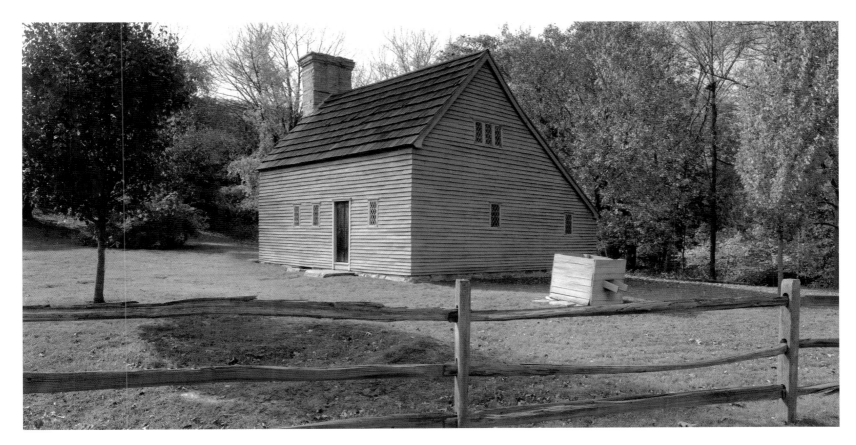

The Clemence-Irons House in Johnston, another "stone ender." Restored
in the 1920s, it is owned and maintained by SPNEA.

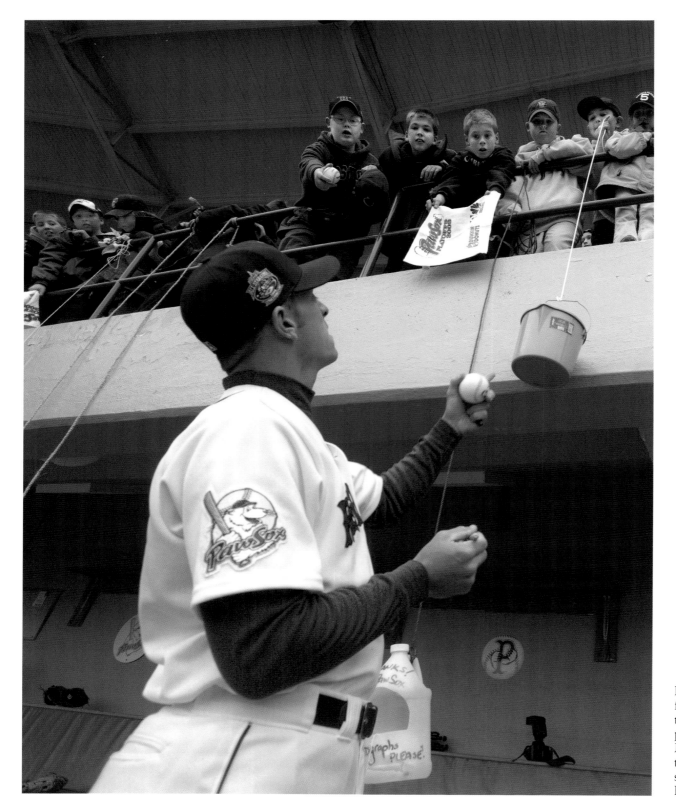

Pawtucket Red Sox out-
fielder Jeremy Owens con-
tinues a long tradition of
pregame autograph signing.
Many young fans know
that Pawsox players may
someday "move up" to
Boston and become stars.

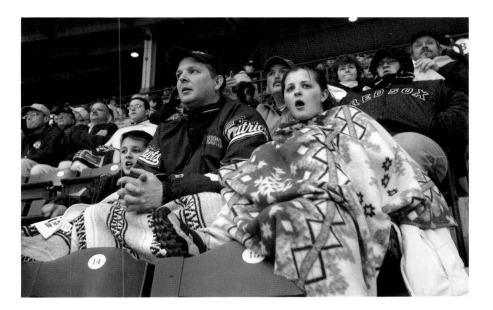

Opening day at McCoy Stadium
in Pawtucket is a family affair for many
diehard fans, despite the often cold weather.

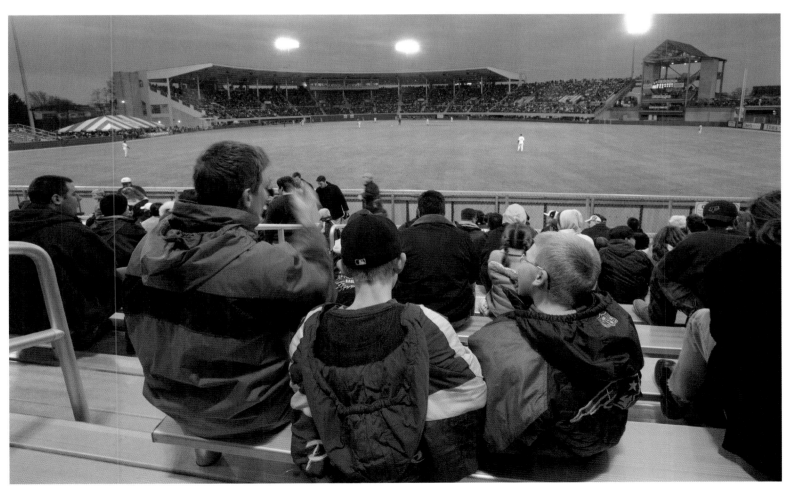

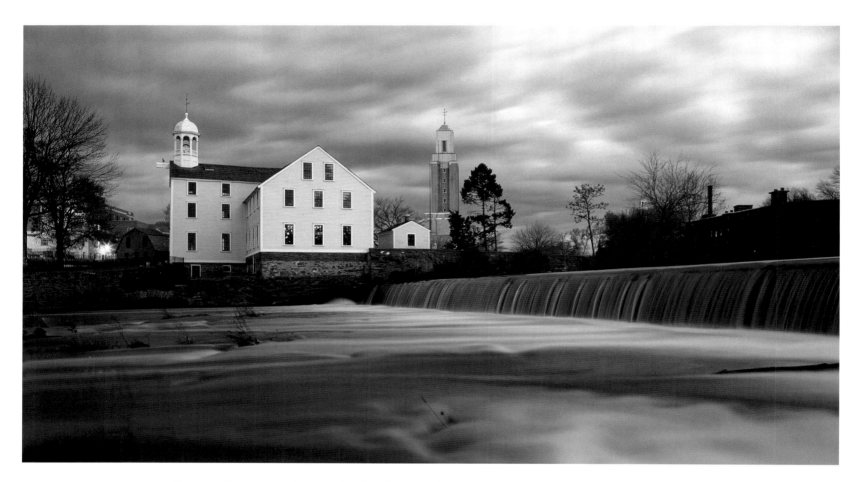

Slater Mill in Pawtucket, said to be the birthplace of the American Industrial Revolution.
Built in 1793 by Samuel Slater, it was America's first successful textile mill.

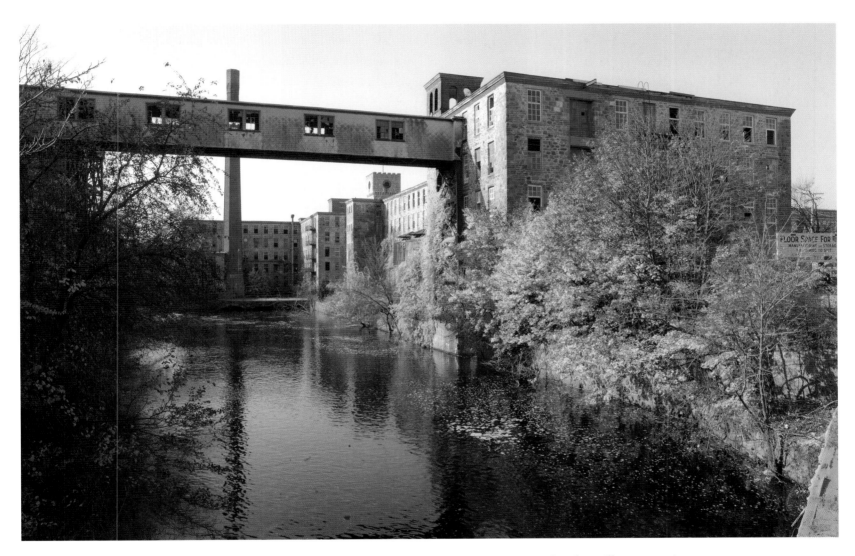

Part of the Royal Mills along the Pawtuxet River in West Warwick. The mills were active in the nineteenth and early twentieth centuries and are now mostly vacant, although some are being converted to apartments and small-business uses.

RENAISSANCE

Once described by the *Wall Street Journal* as "a smudge on the road from New York to Cape Cod," Providence has undergone an amazing renaissance. Thanks to hard work by the Capital Center Commission, Providence boasts brand-new hotels, office buildings, a convention center, a shopping mall, and a new train station. But perhaps the most visible signs of the city's rebirth are the Riverwalk, Waterplace Park, and WaterFire, which bring young and old to enjoy the downtown and all it has to offer.

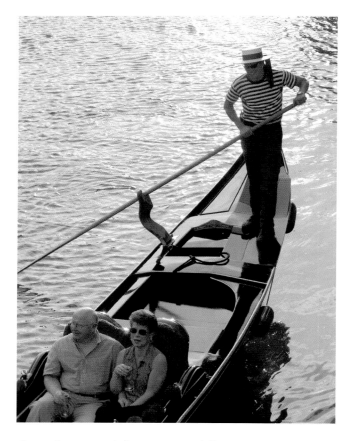

One of two gondolas now providing romantic interludes on a river whose waters were not too long ago polluted and covered by parking bridges

(Right) The newly created Waterplace Park, designed by award-winning architect William Warner

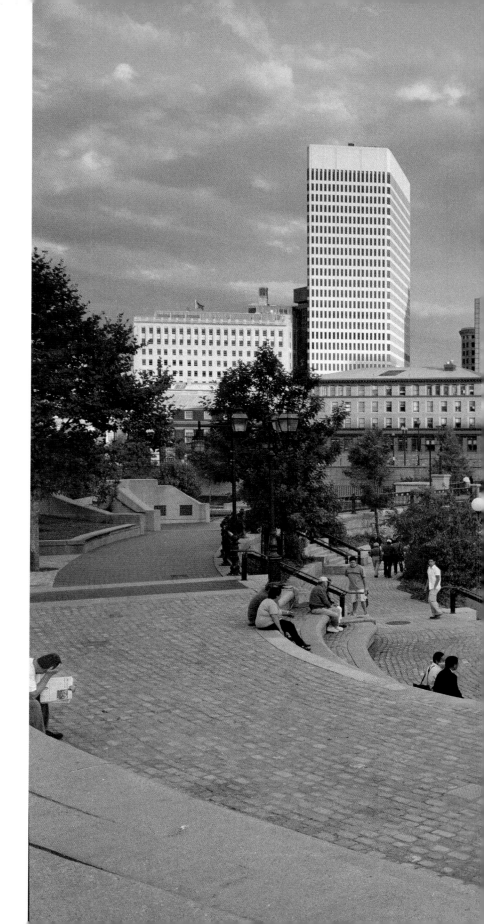

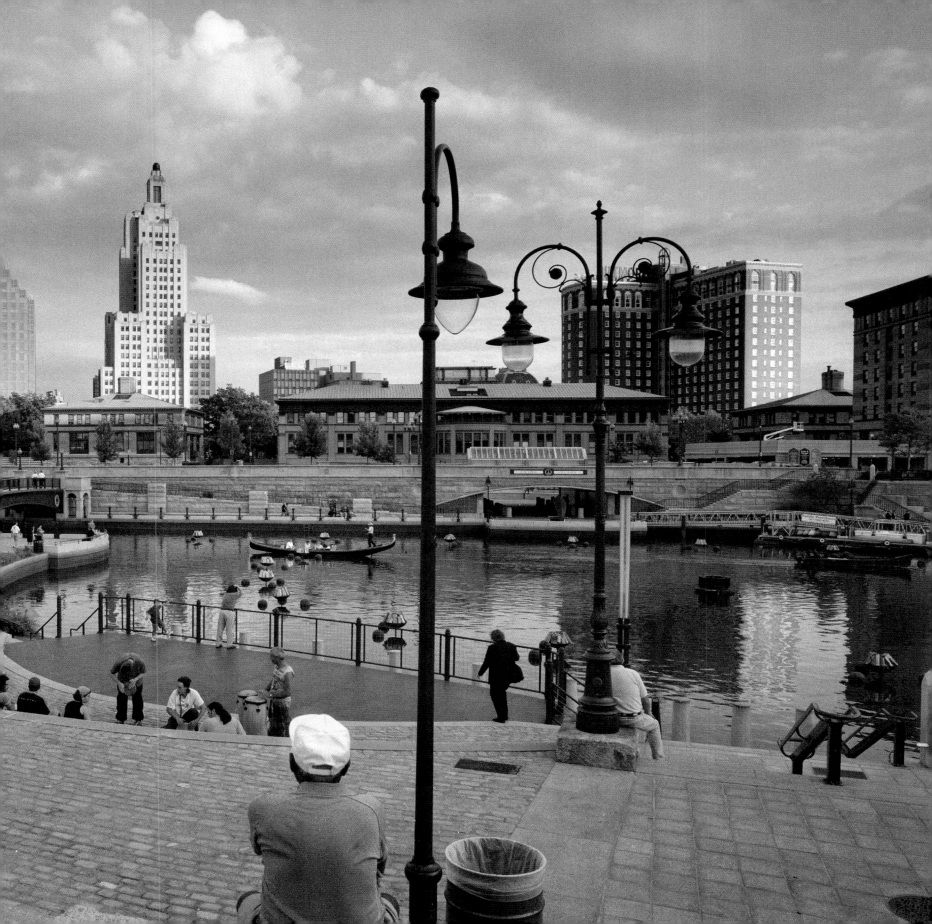

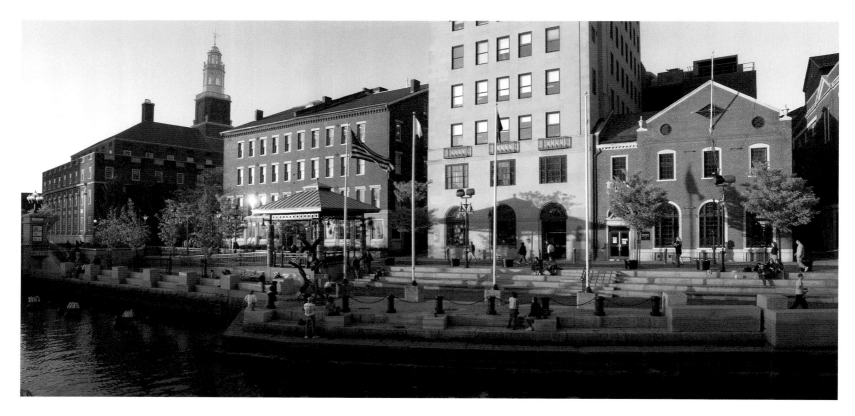

A quiet evening along the Riverwalk. All the buildings in the photo
are part of the Rhode Island School of Design.

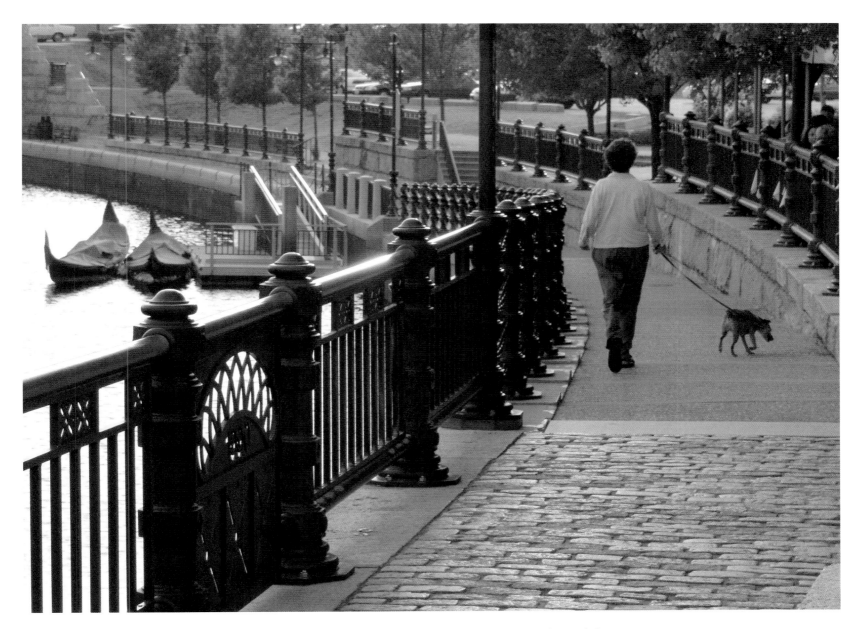

A quiet midweek evening along the Riverwalk, with gondolas
at rest and diners seated at outside tables

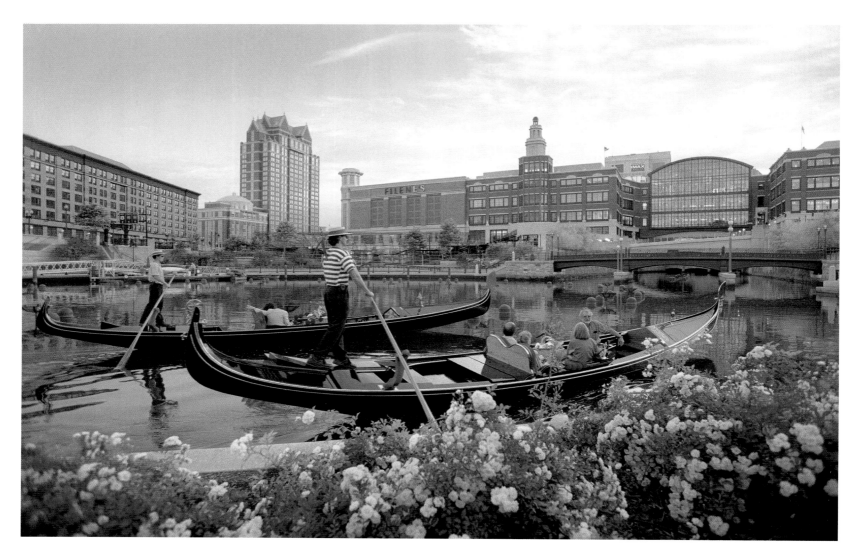

Waterplace Park, with gondolas ferrying wine-sipping passengers. To the left are the
Marriott Courtyard and Westin Hotels, as well as Providence Place Mall.

Anticipating WaterFire, people of all generations gather in harmony along the Riverwalk.

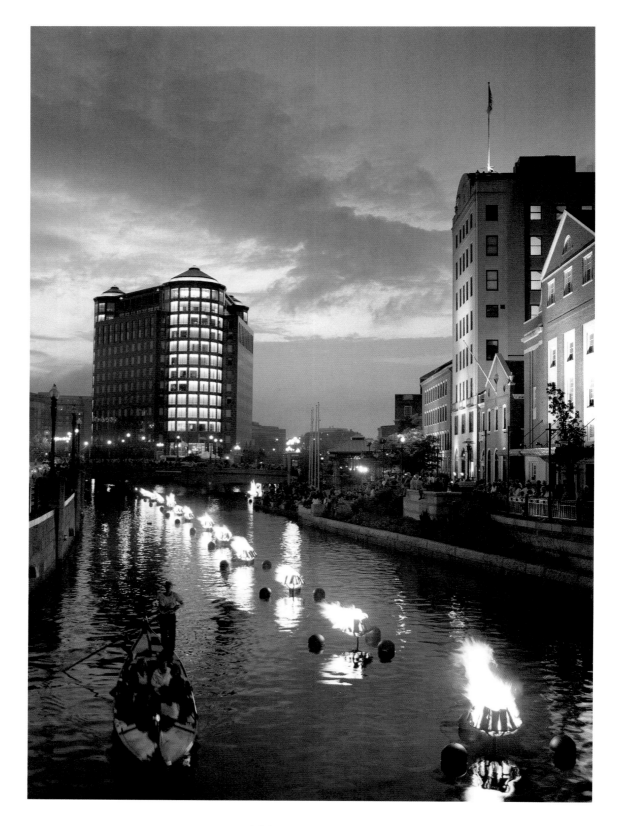

WaterFire, a "fire sculpture installation" designed by Barnaby Evans, features a hundred bonfires burning just above the surface of the three rivers in downtown Providence. From sunset to past midnight, the series of fires illuminates much of downtown. The Citizens Bank Building in the distance occupies a space once known as "Suicide Circle," a notorious traffic rotary. The buildings at the right are part of the Rhode Island School of Design.

(Left) A crew of WaterFire volunteers prepare to light the fires.

(Below) Children of all ages are enthralled by WaterFire, said by many to symbolize Providence's "Renaissance."

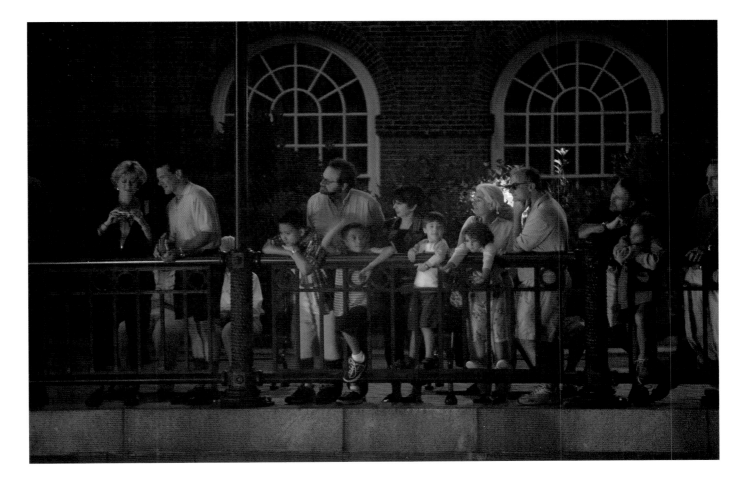

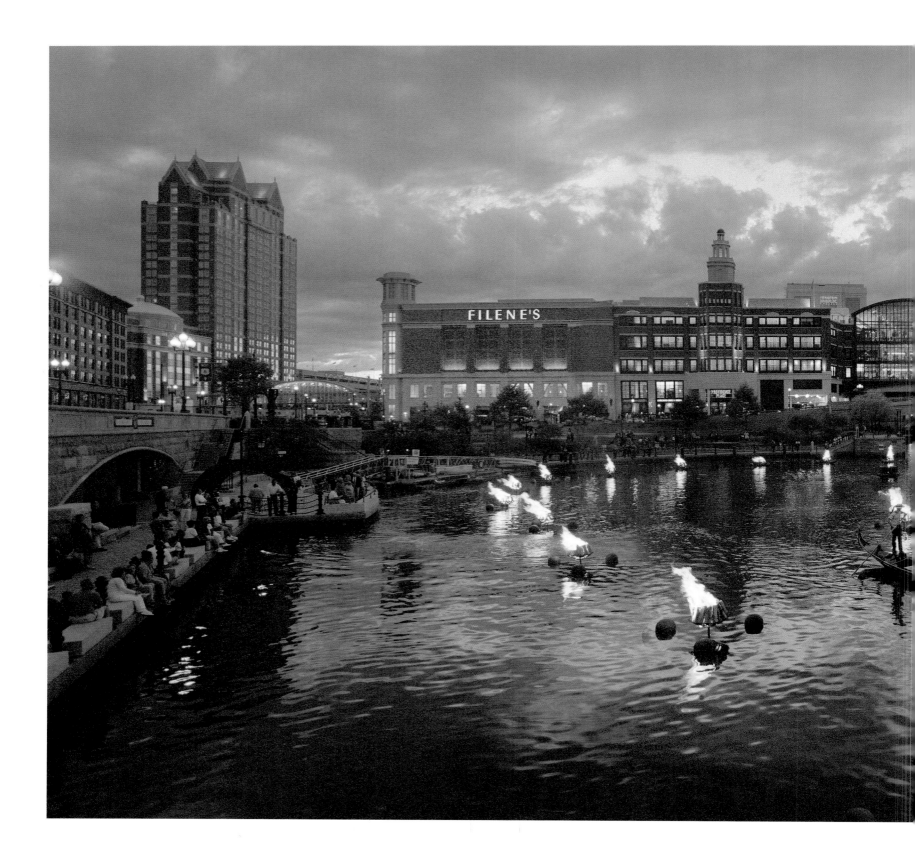

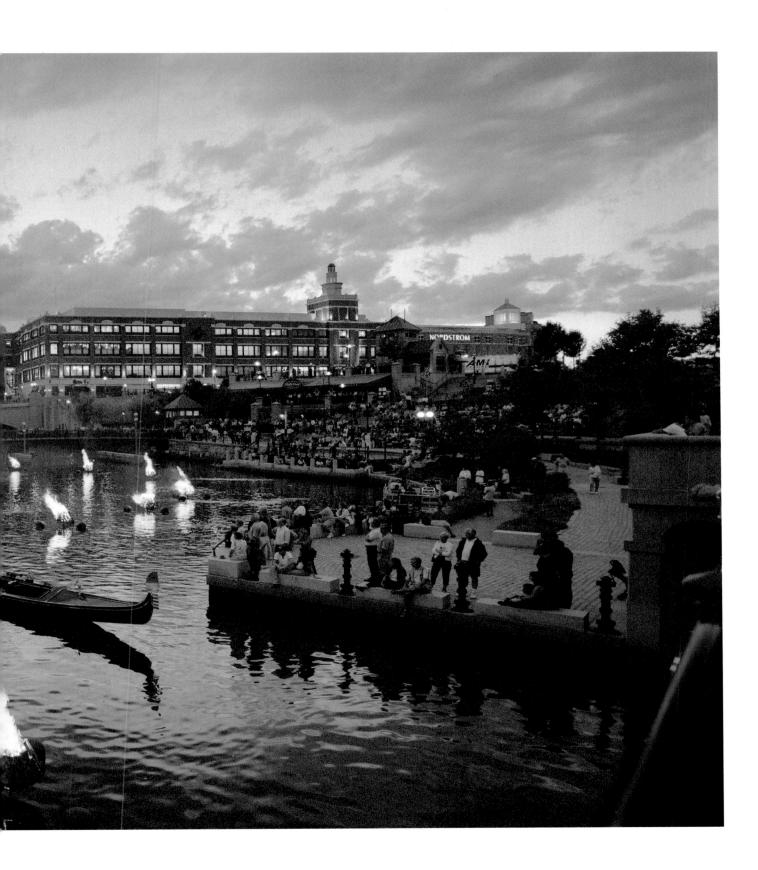

NOTE FROM THE AUTHOR

As a youngster in Woonsocket, I would often wander away from my house. I would always get into trouble for "running away," but I was just satisfying my curiosity about the world around the corner. I always found my way back home when I got hungry! I also have vivid memories of drawing pictures of trees in my grandmother's yard. From an early age I was destined to be a wandering picture maker—or photographer.

Later, while growing up in East Providence, I began to notice the photos in our local newspaper, the *Providence Journal and Evening Bulletin*. The work of one photographer in partic-ular, Winfield I. Parks, Jr., always seemed to catch my eye. I later met him in person when he judged a photo contest I had entered while at Brown University. (I came in second.) Parks became a mentor, and I visited him frequently at the *Journal* photo lab. It was there and then that I decided to become a news photographer. With that as my profession, I could explore the world, make pictures, and get paid. What a deal!

Eventually, I joined the staff at the *Providence Journal* and stayed for twenty-seven years. While there I had the opportunity to work with a wonderful group of talented and dedicated people on every kind of assignment in every part of the state—experience that laid the foundation for this book. On slow news days, staffers without assignments had a stand-ing order to go out and "enterprise"—to go anywhere in the state to find a feature photo or two. Thus I got to explore the state in great detail—and, as a result, I believe I have a road map of Rhode Island permanently engraved on my brain.

Sometime around 1990, at the urging of my wife, Trauti, and my sons, Dan and Mike, I started showing my personal work in a tiny cooperative gallery in Wickford. Then, in 1993, Dan introduced me to David O'Brien, who had just purchased Picture This, a gallery and framing center on Wickenden Street in Providence's Fox Point section. We now are approaching twelve years of working together, having placed thousands of my photos in homes, private collections, and offices in and outside Rhode Island—a pretty nice way to make a living since "retiring" from the *Journal*.

My personal challenge has always been to find beauty in everyday surroundings. Although Rhode Island doesn't have

the majestic mountains or the misty redwood forests of the West, it has a quiet beauty of its own. I have learned that ordinary locations can be seen with fresh eyes during a snowstorm, with all its shades of white, or at dawn and dusk, when the sun and clouds seem to perform magic. Those who are safely at home during storms, or in bed at dawn or dining at dusk, seldom experience these fleeting, world-trans-forming moments. I hope these photos help you see and appreciate Rhode Island in a new way. Please enjoy!

I would like to express my thanks to many people for the help they gave me along the way. First I'd like to ack-nowledge Edward F. Sanderson, Executive Director, and Virginia Hesse, R.A., Principal Historical Architect, of the Rhode Island State Historical Preservation and Heritage Commission, Andrea Carneiro of the Preservation Society of Newport County, and Jenna Higgins of the Newport Historical Society for their cooperation and help in photo-graphing historic interiors.

Many thanks are due to my trusted friend and advisor, David O'Brien at Picture This Framing Center and Galleries, for representing my work over the years, allowing me to do what I love to do. There is a direct connection between the display of my work at Picture This and the realization of this book.

Special thanks to a great neighbor, Arthur Cabral, who, without being asked, has kept my driveway clear during many a snowstorm, giving me the time and energy to go out and cap-ture so many of the snow scenes you see in this book.

Many thanks to Webster and Katie Bull, Penny Stratton, Anne Rolland, and all the staff of Commonwealth Editions for the opportunity to do this book and for being so easy to work with.

Finally, a special thanks to my wife, Trauti, for putting up with my odd working hours and my obsession with the beauty of snow storms—and also for tolerating and under-standing the phenomenon of "great skies" that shape up in mid-afternoon, requiring a rescheduling of dinnertime. Without my family's support and encouragement, this book would not be.